so badly need in these difficult days! I thank Lyah Beth LeFlore for her help in laying bare the wisdom of these two geniuses!"

—Dr. Cornel West, *New York Times* bestselling author of *Democracy Matters* and Professor of Religion, Princeton University

"As a member of the legendary singing group The O'Jays, Eddie Levert's brand of silky soul is the reason some of us are here. Gerald Levert has continued to keep the baby-making songs alive. With *I Got Your Back,* these talented men show us another side; the beautiful bond between father and son."

—Mo'Nique, actress, comedienne, and *New York Times* bestselling author of *Skinny Women Are Evil*

"Eddie and Gerald Levert are musical nepotism at its best. Strong 'Man' voices singing harmonious lyrics. If you play one of their songs, you should be able to get you some . . ."

—Cedric the Entertainer, actor and comedian

"I got my start in R&B music with Gamble and Huff's O'Jays, so Eddie Levert will always be important to me. I've been a fan of Gerald Levert ever since he began. To see a father and his son make indelible marks on music over many years is very, very special."

—Clive Davis, founder of Arista Records and J Records, Grammy Award–winning record producer, Rock and Roll Hall of Fame inductee and Chairman and CEO of BMG North America

HARLEM*MOON

BROADWAY

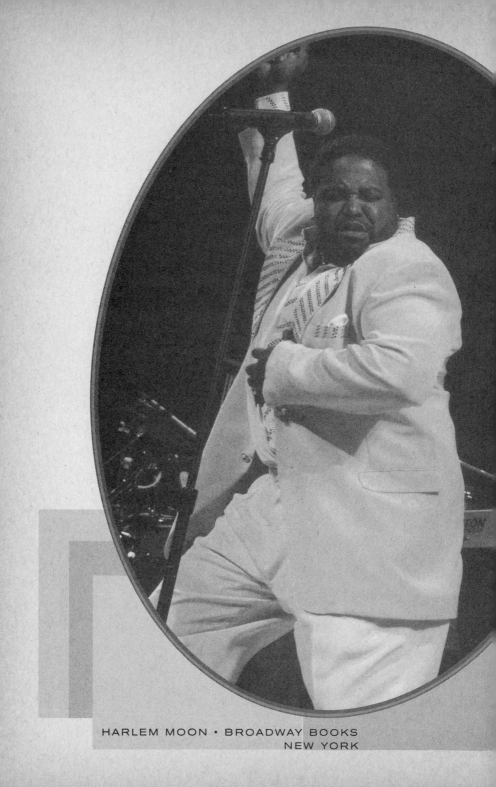

HARLEM MOON · BROADWAY BOOKS
NEW YORK

I GOT YOUR BACK

A FATHER & SON KEEP IT REAL ABOUT LOVE, FATHERHOOD, FAMILY, AND FRIENDSHIP

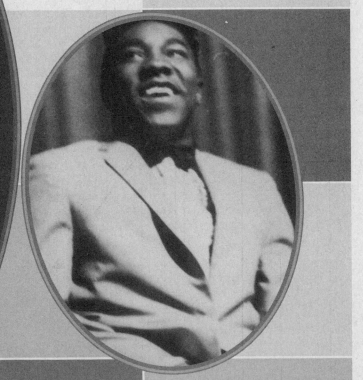

Eddie Levert Sr.

Gerald & Levert

with LYAH BETH LeFLORE

Published by Harlem Moon, an imprint of Broadway Books, a division of Random House, Inc.

HARLEM MOON, BROADWAY BOOKS, and the HARLEM MOON logo, depicting a moon and a woman, are trademarks of Random House, Inc. The figure in the Harlem Moon logo is inspired by a graphic design by Aaron Douglas (1899–1979).

The photograph on page ii is courtesy of Dr. Pamela Jackson. The photographs on pages iii and 12 are courtesy of the Levert family. The photographs on pages 147 and 190 are courtesy of the Levert family and Andy Gibson.

Book design by T. Karydes

ISBN 978-0-7679-2744-4

PRINTED IN THE UNITED STATES OF AMERICA

This book is dedicated to the loving memory of my son, business partner, and best friend . . . Gerald Levert. Each page is a reflection of the enormously strong bond and eternal love we share.

I also dedicate this book to the following people who supported, inspired, and pushed me to dream and become the Eddie Levert the world knows today: my grandmother, Mozell Carter; my mother, Blanche McCloudy; my stepmom, Anna Frank Levert; my dad, Tommy Levert Sr.; my brothers, Tommy Levert Jr. and Andrew Levert; Tom and Dorothy Massey; my first wife, Martha Levert; Pat Dickerson; and my loving wife, Raquel Levert.

EDDIE LEVERT SR.

To my family, who always has my back: my mother, Shirley Bradley Price LeFlore, my rock and best friend; my father, Floyd LeFlore, for your unconditional love and support; my sisters, Hope Price Lindsay and Jacie Price; my niece, Noelle; and to my big brother, Drew, my cousin, Nicholas, and my nephews, Jullian and Jordan. Be inspired by the very special father and son bond shared on these pages.

LYAH BETH LEFLORE

CONTENTS

ACKNOWLEDGMENTS

FROM THE AUTHORS:

Special thanks to our agent, Marie Dutton-Brown.
Very special thanks to our editor, Janet Hill Talbert. This book would not have been possible without your support.

Many thanks to our wonderful Doubleday Broadway Harlem Moon Family: Stephen Rubin, Bill Thomas, Joanna Pinsker, David Drake, Julia Coblentz (aka the Miracle Worker), Clarence Haynes, and Christian Nwachukwu Jr.

Additional thanks to the following individuals

for their professional support: Ashleen Jean Pierre of MBA; Laini "Muki" Brown; Andy Gibson, Chandi Bailey, and AG and Associates family; Amos and Mark; Sean Levert; Kandice Brooks; Leonard "LB" Brooks; Alan Haymon; Joe "Big Joe" Bailey; Edwin "Tony" Nicholas; Kevin Liles, Joi Brown-Pitts and the Atlantic Records family; Sharon Heyward; Patrik Henry Bass and the Essence family; Jeff Burns; Margena Christian; Johnson Publishing Company; Tom Joyner and *The Tom Joyner Morning Show*; Cathy Hughes and Radio One and TV One; BET and BET J; AOL Black Voices; Jamie Foster Brown and the Sister 2 Sister Family; Steve Harvey, *The Steve Harvey Morning Show,* and Boomerang; Patti Webster and W&W Public Relations; Vanesse Lloyd-Sgambati; Sherry McGhee-McCovey; the Nu America and *Uptown* magazine families; Tony Scott, Tammy Holland, Arika Parr of Majic 104.9 in St. Louis, Missouri; Roland Martin and Geneen Harston of WVON in Chicago, Illinois; John Soeder and the *Cleveland Plain Dealer*; and Kevin Johnson of the *St. Louis Post-Dispatch*.

A big "Teddy Bear" thanks to Gerald's devoted fan clubs G Phi G and The G-Spot.

Also a very special thanks to African American booksellers, urban radio, and the black media.

FROM EDDIE LEVERT SR.:

To my wonderful children: Eddie Jr., Gerald, Sean, Kandi, Asha, Eurydice (Uri), Ryan, Jerrell, and Cierra. Thank you for loving me. I'm proud of each of you and love you with all my heart.

To my precious grandchildren, thank you for filling my life with so much joy and love: Lemicah, Carlysia, Camryn, Kennedy, Logan, Chad, Sean Jr., Brandon, Breoine, Sharium, Keith, and Kaidyn.

To my wife, Raquel Levert, thank you for your unconditional love and standing by my side.

For Martha Levert, my first wife, thank you for being a wonderful mother and friend.

For Walter Williams Sr., my brother, my friend: We have weathered many storms, and we're still standing strong making great music. Thank you for having my back for over fifty years! I love you, man.

To Eric Nolan Grant: Keep your eyes on the prize!

To former O'Jay Bobby Massey: Thank you for helping a brotha when he was down and paving the avenue for me to get to where I am now.

FROM LYAH BETH LEFLORE:

Thank you Eddie and Gerald for entrusting me with your stories, secrets, joys, pains, dreams, fears, and your most precious treasure, your bond as father and son. Gerald, your spirit guided me to the finish line. I miss you!

Thank you Martha Levert for trusting me with your scrapbook and photos. You embody all the beauty, inside and out, Gerald always spoke so proudly and fondly of.

Kandi and Sean, I feel privileged to have been able to tap into the special bond you shared with Gerald as siblings.

Thank you Alan Haymon for your friendship and sup-

port, and encouraging me to call Gerald and take flight with this idea.

Thank you Andy Gibson for keeping it all together and being a cheerleader throughout this incredible journey.

Thanks to Chandi Bailey for coming through for me every time I called the office with an "emergency."

Special thanks to my agent and mentor, Marie Dutton Brown, for your passion, belief, and countless editing hours. How ironic was it that within forty-eight hours you lost your very close friend who loved music with all his soul, and I lost such a good friend who created music from his soul. This is for Edward and Gerald!

Janet Hill Talbert, my editor and friend. From the moment you saw Gerald and Eddie onstage in Washington, D.C., at the Warner Theater in May of 2006, you felt the power of their very special father-and-son relationship and knew it needed to be shared with the world. You allowed me to spread my wings and step away from fiction to write this very important book.

Tynisha Thompson, my publicist, marketing guru, and friend who is always on call and ready to jump in the trenches with me.

Charles Wartts, a brilliant writer and scholar, thank you for your editing expertise and guidance.

To my cousin-girlfriends: Karen, Missy, Passion, Valerie; my other big sister Theresa: It's been a long haul, but you pushed me not to give up.

More Family Thanks: Aunt Cynthia, Francis Crawford, Vola and Eugene Washington, the Bohrs, the LeFlores, the

Robnetts, Keylee and Pat Page and my Decatur family, the Davises, Bradleys, the Price-Moores, and the Lindsays.

Thanks to my amazing sistafriends: Mamie, Dione, Leah, Tizzi, Wendy W., and Sherry B.

And to my guardian angels: Minnie, Annette, Munroe, Floyd Sr., and Barbara. Thank you.

I GOT
YOUR
BACK

LAS VEGAS, NEVADA
DECEMBER 13, 2006

Eddie Levert

I remember when Gerald was about ten or eleven, Sean must've been eight or nine, I'd be home, in between recording and touring, and take the two of them down in the basement where we'd have impromptu jam sessions. Sean would get on the drums, Gerald and I would be on the keyboards, and the three of us would sing and write songs together. I really got a kick out of just hanging out and making music with my sons.

Once they got a little bit older, I started taking them out on the road with me and The O'Jays. Even

back then, I recall how focused and determined Gerald was to be in show business. My whole life had been about singing, but the entertainment business demands a lot. You have to be a strong individual to take the success as well as the rejection.

It was a long struggle before me and The 'Jays got our first taste of success, in the early seventies, and I knew the dark side of the record business. It's a hard business, and if you don't have the heart to keep up the good fight, it can swallow you up. I wanted to protect my kids from that. I felt like at least one of them should be a doctor or a lawyer, something that was stable. Gerald probably got his "calling" to do music when he was a baby. When he told me what he wanted to do, I tried hard to convince him otherwise, but I couldn't.

So, I made it clear to him that to get the fame and be a superstar, you have to be a hit act and write hit records. Bottomline, you have to be someone who the people want to pay money to come and see. I'd been in the show business trenches since the start of the sixties and created a persona for myself. Gerald was going to have to do the same.

I told him, "You've got to become a personality. People have to feel like they know you. It's about sacrifice and you have to give your all, your guts *and* your soul. You've got to dig deep, Man! You ain't heard nothin' until you've heard some Stevie Wonder or Marvin Gaye or James Brown or Otis Redding!"

Then I'd give him videotapes and say, "Here, you need to watch Jackie Wilson and Wilson Pickett, and Ray Charles. You need to know about these people so you know the standard you've got to live up to." He studied them, too, just like he studied me and The 'Jays. Gerald not only became a tremen-

dous performer, but he's one of the best writer-producers I've ever worked with.

As a young artist he took the concert game to another level. Other acts his age sang to prerecorded music (some even lip-synching), but Gerald sang live with a full band, background singers, and classy wardrobe changes. He didn't have to have dancers or special effects. It was all him, and you always got more than your money's worth at a Gerald Levert show, just like with The 'Jays shows.

Gerald was so known and loved, he'd walk into a hotel, or the airport, or even down the street, and fans would call out his name and say, "Yo, G!" That's what his close friends and family called him, but fans felt like they knew him that well. Same with me, fans call me "Eddie"; they never call me Mr. Levert.

Throughout Gerald's life and career, he and I spent hours upon hours on the phone together, talking about what he was gonna do in his show, what kind of music he'd use. He'd vent to me when he was having problems with his record company, and ultimately we'd dream and plan about how we'd move forward in music.

Gerald hated the unfairness in the record business. I'd have to remind him that I went through much of the same things. I could understand his pain. He couldn't hear me at first and would go off, "Yeah, but Dad, it's totally unfair, and they shouldn't have treated you like that, either! You deserve the world and I deserve the world, because we've given them all of *this!*" By "this" he meant great music.

A lot of times he couldn't see that giving great music wasn't necessarily part of the deal. As strange as that may sound, this

business doesn't care how much blood, sweat, and tears it takes to make a great song. It cares about record sales. Nowadays they're dealing with the "flavor of the month." Whichever act has the latest hit song is "it," meaning hot. That's who the record company is gonna cater to.

I'd calm him down and say, "No, Man, don't say that or go kick over the table and make a scene. It'll be all right. Don't worry about the business, just focus on what you have to do, Gerald." I had to make him understand that the music that he and I were making was the real deal.

We were helping people with their relationships, helping them raise their children and get through their workdays. I'd tell Gerald, "You're not like the flavor of the month! You're gonna be here forever. People use you as an example for the way they walk through life!" I'd talk to him straight up like that, because I wanted him to see that, without another hit record, that same "flavor of the month" artist will be gone tomorrow, while Gerald had staying power.

Gerald would joke, "Okay, okay, but Dad, you know the problem is that we're just too nice. We need to have scandal! We need to have controversy. Everybody who's big now has controversy and scandal in their lives, and they get all over the front pages of the papers, and they're all on *Oprah* and the *Today* show. Look at Bobby Brown and Flava Flav! When people ask us, 'Well, what's your story?' We can't say anything! We've done *nothing,* Dad!"

We'd go back and forth until I'd finally stop him and say, "No! Man, I think we might go *way* over the edge if we do something scandalous!" Then we'd break into laughter for about twenty minutes. I could feel his smile through the phone

and he'd tease me one last time, "Man, you are a crazy negro."
Now, this is my son talking to me like that! He was my son, but
he was my best friend and that's how we communicated with
each other.

Sometimes we'd start talking on the phone early in the
morning and talk all throughout the day. After that we might
not talk for a week or so. My wife, Raquel, would hear us laugh-
ing and talking so loud, she'd just shake her head.

When we were done, I'd tell my son I loved him, he'd do
the same, and we'd say good-bye. On many occasions, after
hanging up the phone, I'd sit back in amazement at the fact
that Gerald was always trying to come up with ways to further
both of our careers. For him, it was always about the family
getting ahead.

Gerald could be pretty adamant about doing something his
way, too. I learned that it was best, instead of fighting with him,
to go along with what he wanted to do to try and make his idea
work. However, when it didn't work his way, he'd be the first to
say, "Dad, I think we need to regroup and go back and try it
another way." We were both able to admit when we were right
or wrong.

Some days we'd agree to disagree, but we never ever stopped
loving one another. There was never a day when I got off the
phone with him, or we parted company that we didn't say, "I
love you, Man." Our talks, in person or over the phone, were
nurturing for both of us. No matter how we fussed or fought, it
always came down to this simple rule between us: No money, no
man, no woman, nobody can change the fact of me loving you.

Gerald loved the idea of sensationalism, but instead of us
making our mark in the gossip columns, we chose to be sensa-

tional onstage together. When we performed, we weren't afraid to roll on the floor, hop on top of the speakers, or even run across the stadium floor and jump in a big girl's lap! As long as it was tasteful, and within the context of the show and the song, it was fair game.

We had this theory that with show business, you're always on the edge of making a fool of yourself. One step the wrong way and you go too far, but just the *right* step at the *right* time, in the *right* direction, and you are a genius.

In late October 2006, Gerald and I traveled to South Africa, where we toured and performed in Johannesburg and Sun City. Perhaps it was the single most memorable time of the thousands of shows we've performed together throughout our careers, when I truly felt that manifestation of genius. I had no idea that it would be our last trip together, or the last time I'd ever perform onstage with my son.

Those nine days Gerald and I spent together were a rebirthing of my own passion and drive as an artist. We did our usual laughing and joking, talked about the release of his upcoming CD, and the biggest joy for me was planning another *Father & Son* album and summer tour.

Performing onstage in both Johannesburg and Sun City in front of stadium-filled crowds of fifteen thousand people was a tremendous spiritual experience for both of us. Everywhere we looked, we could see beautiful African brothers and sisters singing our songs. What really brought our trip full circle for me was meeting Nelson Mandela.

I think Gerald and I were both what's called "starstruck." It was humbling to be in the presence of this great man who exemplified strength and peace. A man who had endured strife

and imprisonment for standing up for the rights of his people, *our* people, and later rose to become president of the same country that had persecuted him.

Mr. Mandela told me how he admired the bond I shared with my sons. I was blown away and carried that feeling with me on the long flight home. It was clear to both Gerald and me how powerful our music, message, and our relationship as father and son really is.

On November 10, 2006, less than a week after we returned from South Africa, I got a call that Gerald was being rushed to the hospital and they couldn't revive him. My first thought was: Okay, now I've got to gather all my resources to help my son successfully recover. I just kept telling myself, "He'll be okay. I've got to get him back together again."

Then I got a call and the voice said he was gone. I lost all feeling. A part of me had been ripped away. My soul had never been so heavy. At that moment, I would've given up everything I had to see my son's face again. Just to get up on that stage and sing together again, one more time. In reality, all the money and other resources didn't mean a thing.

My son was gone.

I will probably replay the tenth of November in my mind over and over for the rest of my life. I think about my own childhood back in Canton, Ohio, and my relationship with my father. I can't remember my dad hugging me very often, but I can remember him being a very strong man, and not just physically. His strength was in the way he took care of his business, working hard to bring home his pay, feed his family, and put a roof over our heads. I hope Gerald saw the same strength in me.

My father believed that how you treated a person showed how much you loved them. Not a bunch of hugging. I suppose that's why I was never really a touchy-feely kind of guy before I got married to my first wife, Martha. When I became a father and I had my own family, I suddenly had this strong connection to my kids. It became important for me to physically hold them to show them how much I loved them.

I really got into hugging my kids and was proud of that. In fact, my kids are probably the only people I embrace with both arms. Gerald and I would always exchange these great "man" hugs. My son was always much larger than me in stature, which made our hugs even more memorable. God, I miss his hugs.

A lot of people will say Gerald had my laugh, but I call it his. They compare his smile to mine, but his smile was undeniably Gerald. I miss that smile, that laugh. I even miss when he got pissed at me, or I was pissed at him. I would always tell him that he had to stop giving so much of himself to everybody. I wanted him to try to hold a little bit of "Gerald" back for himself.

His final album is called *In My Songs*. It features music from his club jams, to his deep and introspective songs about love. In the title track he says: *I want someone I can be lovey dovey with, I want someone that I can wake up with, I want someone that I can stroll through the park with, someone that I can be with like the ones I sing about in my songs . . .*

He was constantly looking for that perfect love, too. I'd say, "G, you've gotta start off liking a person, then you'll learn more about them, and the next thing you know you'll look around and all of a sudden you'll love them."

I feel like if he'd had a woman he loved in his life, sleeping next to him, she could've woken him up or taken him to the

doctor. She could've called someone to help him get through that night. Sure, he had his cousins living with him, but that's not what I'm talking about. He was alone as a man.

When I think about the title of this book, *I Got Your Back*, it epitomizes who we were as father and son. I literally feel like I had his back on everything, but I guess I couldn't help him find the love of a wife that he longed for. I couldn't do that for him. I discussed these things with him more seriously in the last year of his life.

I wanted him to find someone he trusted and believed in, someone who made him happy. The autopsy report cited that his death was due to a heart attack. I say my son really died of a broken heart, because he never met the woman he wanted, needed, and really deserved.

Instead, he poured his love into creating great music, and he gave it unselfishly to fans, his family, and his kids. Perhaps that was his calling. I'm just so thankful for the time I had him here with me. I have memories that no amount of money can buy. Memories I hold close to my heart, and no one can take them away from me.

Some of the greatest times of my life were when I was performing onstage with Gerald. Gerald and I didn't have to rehearse. It was what I like to call "all natural"! We'd feed off one another. He'd goad me on, "Where's that Eddie Levert that I keep hearing is the man? I need to see him!" Or he'd say, "Dad, you're throwing me the ball but it's coming *real* slow!" That would really get me pumped up and I'd say, "Boy, you'd better back up and leave me alone!" Audiences would go crazy.

Through his passing, I have the desire to be an even better artist. I have to show the world that our legacy—mine, Gerald's,

and Sean's—was not a fluke. Gerald's music was real. I passed the gift on to him and Sean, and we do what we do because it's a God-given talent. I always told him that God sets the tone for who you're gonna be, where you're gonna be, and how long you're gonna be here. I have to accept that God had another plan for Gerald.

It occurred to me the other day that Martin Luther King Jr. was only thirty-nine when he died. Gerald was forty. I believe my son had the same kind of spirit as Martin did. Gerald hated injustice. He felt it was his human duty to stand up or speak out for one of his siblings, or a cousin, or his friends. Gerald was always talking to me about things that were bigger than just "us."

I think Gerald was one of the most selfless people I knew. His heart was equally balanced with passion *and* compassion. Gerald was always trying to figure out how we could better our way of thinking and use our music to heal the ills and wounds of the world and black people. He wanted black men and women to understand each other better. Gerald was about walking the walk, not just talking the talk. There are people who live to be 80, 90, even 100 years old and never do anything that has an impact on anybody, but Gerald did.

Gerald knew, even at that very last moment when he closed his eyes, that his mom and I, and his children, and all his brothers and sisters loved him. We knew that he loved us, too. What's important now is that his children know how much he loved each of them, and that his music lives on for the millions and millions of fans who adored him.

On November 14, 2006, nearly seven thousand people lined up to attend Gerald's public memorial service in Cleve-

land. Stevie Wonder sat in his plane all night long just to get there. Patti LaBelle flew in from overseas when she heard Gerald had passed. Great artists like Stevie and Patti were my friends, and I introduced them to Gerald. They watched him grow up onstage. When he got older, he even performed and recorded with them.

It was awesome to see the outpouring of love and support from Gerald's contemporaries like Angela Winbush, Yolanda Adams, Johnny Gill, Keith Sweat, Brian McKnight, and actors like Kim Whitley, and Mo'Nique, as well as artists he discovered, Men at Large and the Rude Boys; and of course his brother Sean, and childhood friend Marc Gordon, who were his fellow LeVert members, among so many other stars.

Knowing my son lived a full life in his short forty years is my comfort, and that helps me to find peace. I've decided that when I do see him again, I'm gonna say, "Well, you finally got your sensational story, Man. But I didn't like it!"

One of my last prayers to him went something like this: "Hey, Man, I got the funeral services done as low-key as I could, but I couldn't stop the celebrations, parties, and tributes that went on from Chicago to Detroit, Atlanta to St. Louis, Houston to Los Angeles. People all over this country felt your spirit!"

Perhaps the masses will do the same for me when I'm gone. Maybe not on the same magnitude; somehow I think my son touched many more people on many different levels. He was a son, a brother, a father, an uncle, a nephew, a cousin, a friend, and most important a good human being. I lived the saying "I got your back" each day with Gerald.

This book is a tribute to my son and the special relationship we shared. It is our testimony of our love for each other, our

family, our music, and our fans. *I Got Your Back* is the final per-
formance we shared together. Our conversations on these pages
are a reflection of the musical footprints and
foundation that Gerald and I laid, from
The O'Jays, to LeVert, to his solo
career. This book is our lives beyond
the spotlight. A journey all fathers
and sons can claim and all families
will be able to relate to. And as
Gerald would say . . . "Love you,
don't ever change!"

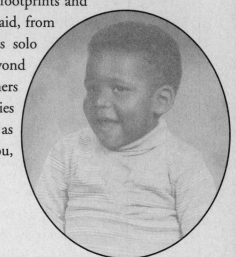

I Got Your Back was completed on Thursday, November 9, 2006, the day before Gerald passed away. In late 2004, Eddie, Gerald, and I embarked upon a journey that would be life altering for each of us. The journey was the task of writing this book, and many of the feelings Eddie and Gerald revealed to each other in the various conversations I recorded and witnessed, they'd never shared with each other before.

As an African American woman, I was honored to collaborate with Eddie and Gerald. We wrote the book over the course of a year. I spent time with them

in Cleveland, Los Angeles, Las Vegas, and New York. Ultimately, not only did we create a powerful book, but I also got a better understanding of my own father, and the lessons and insights I gained from Eddie and Gerald strengthened my bond with him. It was a healing experience for all!

At one point we were going to change the title of the book. I remember calling Gerald, saying, "Our editor wants us to consider a different title. So, *I Got Your Back* is out, and we need something new by tomorrow!" Gerald asked me if I was crazy, telling him that he had to come up with something that quick, and I told him yes! The next morning he called me back and said, "Okay, check this out, how about calling it *Gerald, Holla at Your Dad.*" I held the phone for several seconds in disbelief, wondering how I was going to go about telling a genius, "I hate it!"

Before I could stop myself, the words had flown out of my mouth, "Holler at your dad? What the hell is that? Now *that* sounds crazy!" Gerald started laughing so hard he could barely continue the conversation. He finally collected himself and said, "Naw, you pronounce it *holla* at *cha* dad!" I told him they would laugh me, him, *and* his dad out of Doubleday. He tried his best to convince me that brothas in the 'hood would love it. In fact, they'd love it so much it would become the *new* thing to say in the 'hood.

Thankfully, our editor Janet Hill called me back and told me we were sticking with *I Got Your Back.* However, Gerald's backup title became a running joke between us. Every time he said something I thought was lame, I'd tease, "Oh, I think we just had a 'Gerald, holla at cha dad moment!'" Then he'd let loose that big beautiful laugh.

What you'll read in the following pages is that incredible journey with two men who are very special to not only me, but to millions and millions of music lovers around the world. The experience is bittersweet, but blessed because Gerald's last album, *In My Songs,* and this book were the final projects he completed before his death. They leave behind a spiritual legacy as well as a musical legacy. I don't question how we finished the book on the eve of Gerald's passing. All I can say is that I believe one word sums it up . . .

Divine.

INTRODUCTION

LOS ANGELES, CALIFORNIA
JANUARY 1, 2006
COAUTHOR LYAH BETH LEFLORE

Growing up, Saturday mornings my mother would turn the stereo up as loud as it could go, and our house, and probably the entire block, would come to life. The aroma of a good ol' Southern-styled breakfast—by way of St. Louis—complete with biscuits, sausage, eggs, and grits, teased my nostrils. And my two sisters and I set about doing our chores that were always a little less demanding with the aid of a good groove.

"Back Stabbers," the chart-topping, classic, midtempo ode to playa haters trying to take a brotha's

woman, was always in heavy rotation. The sound of that crescendo-ing acoustic piano run in the opening chords of the song seemed to bellow from the backwoods of an old-time Mississippi revival meeting, and was backed up by a foot-stomping rhythm section, soaring horns, and lush, haunting strings. Then came those harmonious, melodic vocals of The Mighty Mighty O'Jays, dominated by the one and only Eddie Levert. Eddie could let out a field holla that screamed all over your soul, made you feel good and want to get all the way down. "Right on! Right on!" as Eddie would say.

In the seventies, The O'Jays' music was definitive of a time in America when black people were proud of their blackness. My parents dressed in colorful dashikis and donned afros. I marveled at my father, who played the trumpet, sported a goatee, and smoked Kool Mild cigarettes. Like Eddie Levert on the album covers stacked next to the stereo, he was cool. It was also a time when community leaders were empowered to take a stand, as The O'Jays called on the government to "Give the People What They Want."

The O'Jays' music brought black families like my own together in ritualistic fashion: to share stories from the ancestors, to laugh, cry, enjoy good cookin', and dance to the timeless family anthem "Family Reunion." It was all about spreading love, black men respecting and honoring black women—and of course makin' love.

In 1986, I was sixteen and LeVert's number one R&B hit, "(Pop, Pop, Pop, Pop) Goes My Mind," would reflect my own teen love angst. Every boy in school thought he was a Casanova. And by the time I got to college, we were all "Just Coolin'." The O'Jays' songs had spoken words of love and wisdom to my par-

ents' generation, and now Eddie's sons Gerald and Sean were speaking to mine.

The Levert name has been synonymous with legendary music families such as the Jacksons, the Winans, the Mills Brothers, and the Neville Brothers. Eddie Levert is an artist who, by his own admission, *loves* to sing and perform. His passion goes beyond fame, accolades, awards, and even money. When he passed his musical gift, dreams, and passion on to his sons Gerald and Sean, a legacy was born.

Following in his father's footsteps, Gerald Levert soared to new heights, rising to R&B superstardom: first as lead singer of the multiplatinum-selling trio—LeVert—where he shared the stage with his younger brother Sean and Marc Gordon, and ultimately as one of R&B's biggest-selling solo artists.

With Eddie's heart-stopping, electrifying, raw-soul vocals and Gerald's smooth, rousing ballads and funky workouts, the music of this powerful duo has reached out to touch the multitudes. As father and son, they have made music a family affair and are legends in R&B, soul, pop, and rock & roll.

Eddie and The O'Jays have been making great music for over fifty years, and Gerald for another twenty. Yet, despite the ever-changing climate of the music industry, these awesome performers have sustained their popularity. The Levert pulse makes folks move, groove, shout, stomp, scream, and cry.

Their lyrics reflect political and social issues ranging from concerns about unemployment and family to meditations on relationships. The heart and soul of their socially conscious music and message crisscrosses cultural and generational boundaries, and transcends race, creed, color, and religion.

Along with hits from a select group of popular "soul men,"

Eddie and Gerald's music has created the soundtrack to my life. It was beyond a dream come true when I got the opportunity to work with The O'Jays for the first time in 1994, on the ground-breaking Fox television series *New York Undercover.* I remember the day Eddie arrived on set. The energy on the production floor was electric. The crew had been buzzing for days, reminiscing about every O'Jays hit ever made.

The O'Jays—Eddie, Walter Williams, and former member Nathaniel Best—arrived right on time (old-school artists show up on time, ready to work, and on top of their game). I was not only floored by how down-to-earth these music icons were, but so much more impressed by how they made a point to sign every autograph in the room. Eddie and Walter, as original members of the group, epitomized class and style.

Just prior to when the cameras started rolling, Eddie noticed me racing around, making last minute on-set preparations. I felt a gentle touch on my shoulder and turned around to find Eddie, giving me a reassuring, fatherly wink. He whispered, "Slow down, darlin', it's all good." Suddenly, à la Oprah, I had an "a-ha moment." Eddie's quiet gesture reminded me of my father. My dad isn't big on words, but he can put me at ease with just a comforting nod.

And just like that, it was back to the business at hand. As the set director cued "For the Love of Money," Eddie broke into the song's opening dance move then flashed his signature thousand-watt smile, lighting up the entire room. Walter followed suit, doing a smooth spin and chiming in with his silky falsetto lead. Meanwhile Nathaniel, the youngest member of the trio, who had just stepped into the big shoes of the ever-revolving third member, was working hard to keep up.

We all watched in awe as The O'Jays slid effortlessly across the stage. It was just like 1973 all over again! For a few minutes the cast and crew forgot we were shooting a television episode and were transported to a Studio 54–style disco, surrounded by strobe lights and glitter. While others went back in time to a down-home house party. You know the kind, where the music is so good you don't even mind sweatin' out your freshly pressed "do."

Gerald appeared on the show a few episodes later, and watching him perform was reminiscent of his dad, but with "new-school" flavor. As we all looked on in amazement, it was as if Gerald was channeling Eddie right before our eyes—spinning, gyrating, and grinding. When he hit certain notes, you could actually close your eyes and *see* Eddie. Meeting father and son on the set of *New York Undercover* laid the foundation for the long-standing and close friendship I've shared with both Eddie and Gerald for nearly fourteen years.

In the pages of this book, Eddie and Gerald share their warmth, candor, humor, and down-to-earth banter, especially Gerald's robust sense of humor, which mirrors Eddie's. And as you read, you'll hear their voices speaking from the page. You may find yourself reflecting on your own relationship with a father, grandfather, uncle, brother, or cousin.

Beyond all of the accolades and awards, Eddie and Gerald are first and foremost gentle, determined, insightful, brilliant, and strong black men who make you feel so comfortable that you almost forget that they're internationally known superstars.

What inspired me most to take on this collaborative project with Eddie and Gerald was the fact that, despite career ups and downs, multiplatinum album sales, and sold-out concert tours,

they've always managed to stay grounded, never losing sight of the values and importance of family.

As a woman I was particularly compelled because of the close relationship I have with my own father. However, I realize that there are many sistas in our communities who are single mothers. Many don't know their own fathers. Through Eddie and Gerald's story, they can not only find personal healing, but encouragement and direction in raising their young boys to become responsible, caring men.

Eddie and Gerald's courage and commitment to each other also speaks volumes at a time when young black men are being incarcerated in disproportionate numbers, families are being ripped apart, and our communities are in a virtual state of emergency. They believed, now more than ever, that black men need to be recognized, honored, and lifted up.

In *I Got Your Back,* Eddie and Gerald keep it real by candidly voicing their personal insights and perspectives on a range of timely topics that impact the lives of black men: family, career, community and spirituality, and love and relationships. They share and discuss issues that reveal and reflect their experiences and observations, including absenteeism, sibling rivalry, career challenges, and women.

Eddie and Gerald reinforce the value and beauty of the bond they share as father and son by also highlighting the positive relationships of countless other black men. In the chapter titled "Unity: Shining the Light on the Fatherhood Movement," Eddie and Gerald do just that: shine the spotlight on some of the dedicated community activists who have accepted the call to action in today's growing fatherhood movement. At the same time, father and son both freely admit that they've

made their share of mistakes, from infidelity to spending more time on the road than with their children. Mistakes they aren't proud of, but the good news is that they take ownership of their shortcomings, and through the power of forgiveness and love have atoned for their past.

I Got Your Back is not a fairy tale . . . far from it. It was written in the same spirit as the song lyrics in Eddie and Gerald's music and is filled with intimate confessions of their own foibles and failures as black men, proving that they're not infallible just because they've made hit records. In this book Eddie and Gerald speak the truth, and with God's grace errors in judgment are acknowledged, communicated, discussed, understood, and forgiven.

In total Eddie has nine children, including two stepchildren from his second wife, Raquel. However, the book focuses primarily on Gerald and his siblings, Sean and Kandice, Eddie's children from the union with his first wife of more than twenty years, Martha Levert.

I Got Your Back captures intimate, offstage snapshots of father and son unplugged; standing strong as African American men, out of the limelight, one on one, together and with various family members, after the cameras have been turned off and the music stops.

A vignette-style introduction for each chapter serves as an appetizer for a series of frank, insightful conversations and wonderful, moving stories from Eddie and Gerald, many of which they generously share for the first time. Lyrics from some of their biggest hits will connect the alternating voices of this duet.

I Got Your Back's journey is emotionally raw. It will make you laugh out loud, and have you fighting back tears. In this

book, Eddie and Gerald express the fervent hope that these open and earnest reflections will inspire a similar dialogue among black male readers, encouraging them to "come clean" and take responsibility for their actions and heal old wounds; get involved with their communities; build stronger bonds with other men; seek a deeper spiritual understanding of themselves and their lives; and reclaim the connections to their families.

Equally, this outspoken rap session between two distinctly different generations of black men offers black women an intimate, rare, fly-on-the-wall opportunity to eavesdrop on why brothas think, feel, and act the way they do.

As you might imagine, after the sudden passing of Gerald in November 2006, *I Got Your Back* is now more than a celebration of Eddie and Gerald's relationship. This book is also the final collaboration between R&B's much-beloved father-son duo and has been enriched to include tributes and fond remembrances from family, friends, longtime collaborators, as well as many people who had a unique and early role in crafting Eddie's and Gerald's careers.

Producer-songwriter Kenneth Gamble, one half of the legendary producing-writing team Gamble and Huff, who signed The O'Jays at Philadelphia International Records early in their career, remarks that "Eddie's DNA was definitely transferred to Gerald. If you ever got a chance to see them perform they were like one person." Music industry veteran Sylvia Rhone, who signed both the group LeVert, which included Gerald, brother Sean, and childhood friend Marc Gordon, to their very first record deal and also Gerald as a solo artist, notes that "There is a legacy of talent in that family that is incomparable."

I Got Your Back aims to set the record straight. Black men

have gotten a bad rap for far too long. This book challenges its readers to acknowledge and celebrate the love, nurturing, and support that most of us have received from our fathers, uncles, brothers, cousins, companions, and friends; a life-sustaining presence too often consigned to invisibility by the media's negative focus on African American men. Contrary to these media stereotypes, Eddie and Gerald are *representing*, proudly proclaiming, with heartfelt commitment and love: *I Got Your Back!*

PART ONE

Family

Family is one of
the most important
institutions you'll ever
be involved with and
investments you'll
ever make!

—Eddie Levert

Y ou know the family is the solution

to the world's problems today . . .

—"Family Reunion,"
K. Gamble, L. Huff / The O'Jays,
Family Reunion

CLEVELAND, OHIO
FEBRUARY 7, 2006
TREVEL PRODUCTIONS—REHEARSAL

Inside a small, brick warehouse-like building snuggled in the heart of the " 'hood," 93rd and Way, sits Trevel (Levert spelled backward) Productions, Eddie and Gerald's production and rehearsal studios. The main room is dominated by a stage, and the musicians are setting up for today's rehearsal.

The guitarist plucks a few chords while a background vocalist warms up. Eddie and Gerald wrap up the logistics with their cousin and business manager, Andy Gibson, for an upcoming *Father & Son* concert date. The Levert organization is a family affair.

The band starts to play the first few bars of "Family Reunion." Gerald belts out a note. "Man, that's one of those riffs we used to do up in church down south!" Eddie gives Gerald a pound. Although Eddie grew up in Canton, Ohio, and moved to Cleveland at sixteen, he proudly claims his Bessemer, Alabama, roots. "Can you believe we recorded that song over thirty years ago and it's still relevant?" Eddie says. "When I was singing the chorus to 'Family Reunion' in the studio, I was envisioning how powerful it was going to be for people.

"It calls us to honor and remember loved ones who've gone on, and celebrate the matriarchs and patriarchs who've made it one more year. When I sing that song, I give it so much soul and emotion because I was thinking about my own family's struggle, going back to slavery, Man!

"I think it's a song that makes everybody look back at their family history. Plus, you know even at our own family reunions, it's the jam that gets the old people and the little babies on the dance floor!" Gerald lets out a round of laughter. Eddie joins in, then Gerald adds: "On the real, black people need to get back to the basics that song talks about." They give each other another round of father-son pounds.

Eddie begins to reminisce about his years growing up. "I was raised being taught that there had to be two people in the household at all times, a mother and a father, and they both had their position in the family. The mother took care of the day-to-day things, and the father went to work and made the money.

"The father was like the overseer, the truant officer, or officer of the day, who came along and knocked you upside the head with a nightstick to straighten you out if you got out of

line." He lets out a hearty laugh. "Back then your dad was always that threat that your mother could use. She would say, 'I'm gonna tell your dad on you and he's gonna beat your butt!'"

You can instantly see how much Gerald loves to hear his dad talk about the "good old times." He shoots his dad a look and nods. "Some of these kids out here today wouldn't be gettin' in trouble or disrespecting older people if families were like they were back in the day. Hell, you can't step to these young cats or try to reprimand them if you see them doin' something wrong, 'cause they'll try to shoot you!" Gerald interjects.

"It's like folks have forgotten that family is your backbone. A family's supposed to come together and help you get through hard times." Gerald's words echo his father's sentiments. Although Eddie and Gerald represent two different generations, Eddie has passed more than music on to his son. He has passed on strong family values. They both recognize that today's black families are in desperate need of healing.

Eddie

My family is my life, and with my sons I just wanted them to know that even if they weren't singing, I wasn't going to love or support them any less, no matter what they decided to do. I feel like this: If you're the garbageman, be the best you can be. Be number one at it. If you're gonna clean floors, *really* clean up the floors. Be the best at cleaning up the floors, because before you know it they'll be calling you from all over the world to come clean up floors and pay you top dollar!

I look at my life now, I'm sixty-five, and the people who support me are my children and my wife, Raquel! The love I

have for my family is the reason I get up in the morning, strive to be a better person, and, more important, work harder to be a better father.

My family keeps me from falling. They keep me rising up. It makes me emotional, and sometimes I cry, but my family motivates me to keep doing what I love to do until the day I die!

I chose myself to be the leader of my family and Gerald has chosen himself to be the leader in his generation, and I'm proud that he wants more than what I wanted. I remember him saying to me, "Dad, I've got a different path than the one you took." I accept that. It's all about evolution.

Gerald

In our family, me and my dad are the two people everyone looks up to and depends on, but like I always say, men are imperfect, and when you make a mistake it's "Shame on you!" Everyone's looking at you and expecting you to be right all the time. Everyone's asking you what they should do and how they should go about doing it.

For example, somebody may need you to talk to their son, somebody else may need some advice, but I don't always have the answers to everything and, as the successful one, I frequently have to deal with money issues. Those are the times you want your family to understand more, be more concerned with a person's heart and how their health is as opposed to automatically saying "I need this" or "I need that."

It can be a heavy burden to carry, but I'm okay with my role in the family. I think that by watching my dad's life, I learned how to be ready for the day I took that baton. My dad has a say-

ing: "Those who can will step forward, and those who can't will always be in the background."

As far as having my own family, I think I'm much more prepared now to settle down and give more of myself to a family and be able to really raise some children and be a good husband. I love my children very much, but I think ten years ago I was more selfish. I wanted to be able to leave when I wanted to, which is not fair to your spouse or the person you love. I don't think it was time for me to settle down before now.

My dad's life was different. He didn't have anything when he got married. He was in his early twenties and hadn't experienced success, or half the things that life had to offer. Then he and my mom started having kids right away and had to support a family. All of a sudden in 1973, success comes along with The O'Jays' first legitimate big hit song, "Back Stabbers," and the fame just kept coming. People are in your ear every five minutes, you're lonely and you don't know what to do.

My mother was very naïve about the ways of the world. She never understood the kind of temptation a celebrity is confronted with. In regular everyday life you might be tempted to do something, but that kind of temptation doesn't scratch the surface compared to what's going on when you're in entertainment. I'm talking about how every night women are out in the audience throwing their panties onstage, willing to screw you in the bathroom. It's just there for the taking.

Eddie

When Gerald was growing up, the situation in our household was that a lot of things went according to what my first

wife, Martha, who is Gerald, Sean, and Kandi's mother, wanted to do. The father is the leader, the director. He's supposed to be the guy who makes the decisions, but sometimes he can't, and the woman has to. As a man, you have to be able to accept that.

I had to because I wasn't there. I was on the road all the time and I left a lot of decisions totally up to her. Martha would call me to get my opinion about what I thought should happen, but the home was her domain. When I was there, I was able to give my input.

I didn't like being away from home so much, but I didn't have a choice. When I was away from my kids, I missed out on doing a lot with them. However, the one thing I did do was teach Gerald and Sean how to swim and play music. Kandi was just a baby. I really wanted to be able to take them camping, or go fishing, or to the park and do those kinds of things. Maybe I'm being selfish with them, but I feel I missed being that kind of a father.

I had to use a particular brand of psychology to raise my kids from the road over the phone. One time Gerald's mom called me and she told me, "Those children haven't been minding me, and they won't do what I've been telling them to do. They won't clean up their rooms, and they broke into your wine cabinet and have been drinking your wine."

So I tell her to go wake the kids up and get them on the phone. She gives them the phone one by one. Now, I've never been one to candy-coat things. So when they get on the phone, I shoot straight from the hip. I say, "Hey guys, what's going on? How you doin'? Your mom tells me that ya'll have been disobeying her, doing what you wanna do. You've been drinking my wine!"

I went on to say, "You shouldn't mess with my wine, because it's not yours, but what I really wanna tell you is this: Your mom, that's my woman. I married her and I'm not going to allow anybody to disrespect her or do anything against her that I don't like. Now, if you wanna get somebody and treat 'em like they ain't shit, you go right ahead. But don't treat my woman, your mother, like that, 'cause I'm gonna get mad and whup your ass!"

There was dead silence, so I said, "I'm going to teach you a lesson about drinking my wine, too. I want each one of ya'll to go down in the basement and each of you get a bottle of wine. I want you to drink it all, and your mom's gonna watch." Needless to say, they didn't mess with my wine anymore!

Gerald

Bottomline, the father has to be there in order to keep the family together. If he's present, that solidifies the unit. I do agree with my dad that you have to be a strong male figure and not dominate or be overbearing. You have to be supportive of your woman. A father also needs to be supportive when it comes to how he deals with his kids. With my kids I have to listen to what they're saying and not think everything is corny or stupid, just because they're kids.

I'm always thinking about making the next dollar. How are we going to get to the next place in life? I used to get so caught up in that that if it didn't pertain to making money, I wasn't trying to hear what they were saying. But I had to check myself because money is not what it's all about. It's about being there for your children, your family, and giving respect and trying to understand what they're going through.

The way of the world now is very different than when I grew up. You have to be much more open with your kids. My parents were much harder on me, but nowadays kids know so much. There's so much available to them. As a father, as a parent, you have to really try to get into their world.

When you're not married, like me, your focus is definitely more on making money, or taking care of things. But that's not always the kids' focus. They want to talk to you. They want to know what you think about what they're doing. They want to know what you'd do if you were in a challenging situation.

My kids are getting older now. My son Lemicah and my daughter Carlysia are about to graduate from high school. So I have to look at things differently now than I would've two or three years ago. Two or three years ago I would be like, "I don't wanna hear that! If ya'll ain't talkin' about makin' no money!" Now, it's bigger than that. It's about helping them get on the right track, and stay on it, so that they can find success and happiness in life.

> Click a glass for the times we had
> Cherish good memories and throw away the bad . . .
> When all is lost family is there
> So let's give a toast to those who really really care
> —"Click A Glass," G. Levert, E. Nicholas /
> Gerald Levert, *Do I Speak for the World*

Eddie

With Gerald and Sean, I wasn't around to do the simple things like go to the park and play football or baseball, or go to

the movies, or amusement parks, or mess around on the basketball court. I missed a lot of the hanging out that most fathers have the opportunity to do with their sons. If I could've spent a little more time doing those things with them, I think they would've turned out even better than they did.

I really know now what I missed out on, but I do feel like I have somewhat of a second chance now with my new wife, Raquel. I have a family again, and I get a chance to experience some of those things for myself now, and I think that's great. I can tuck my five-year-old daughter Ryan in bed and read her a bedtime story.

At the time when Gerald, Sean, and my daughter Kandi were young, I was too busy down in the basement writing songs, rehearsing a move for a particular song, trying to keep my career going. Back then I really didn't devote my time to my kids.

It's been a long journey to get to Eddie the father "now" versus Eddie the father "then," but it was worth it, and I thank my kids for having patience and forgiveness. That's the biggest reward for me when I think about family.

I tell other men all the time, when you're involved in your child's life it makes a big difference. Kids love spending time with their dads. If men spent more time with their children, their kids would have more positive attitudes.

Other than wishing that I had spent more time with Gerald, Sean, and Kandi when I was married to their mom, Martha, I have no regrets. I think Martha did a great job in my absence. I don't think anyone could've done it any better than she did. Sometimes mothers have to be fathers, too. A father's really being a father when he respects the mother's place and what she's doing.

Gerald

My link to my dad was always through music. When I was out on tour watching him onstage, and being with him every now and then as a kid when he'd come home from the road, those were the things that kept me close to him.

I would be disappointed when he couldn't make certain events at school, like plays or show-and-tell, but I'd get over it really quickly because he'd come home with a new album or with a tape of a new song. I'd get a chance to hear "Love Train" or "For the Love of Money" before anybody else got to hear it. Sean and Kandi weren't impressed by all that. They wanted more of *him*.

When I knew that he was not coming home for good, that's when I really got hurt. I was eighteen years old when he moved out. Prior to that when he wasn't around, I understood that he was "working." Even though he was already on the road, it really didn't bother me because I knew I could look forward to hearing his music on the radio, seeing him in magazines, or watching him on television. I listened to every record The O'Jays made and I knew, by heart, every song they ever recorded from the early sixties on.

Kandi wasn't even a teenager when my mom and dad broke up and Dad left the house. She didn't get a chance to spend much time with him. I think his absence affected her more than me and Sean. We were teenagers and able to go out on the road and see the many sides of Eddie Levert. By the time Kandi was a teenager, he wasn't there at all. Me and Sean are two years apart, and Kandi's eight years younger than I am.

I have a brother, Eddie Jr., who is two years older than me.

He has a different mother. Eddie was living in Los Angeles with his mom. He was in a gang and a lot of his friends were getting killed, so his mother sent him to us. Eddie came with the attitude that he was already a man. He didn't care.

In his mind, he'd "kill a nigga," and that was it! He was a Blood and was like "Fuck a Crip! Fuck blue!" If you wore blue, he'd kick your ass! That was his mentality. When he came to live with us, I was fourteen or fifteen years old. So I kind of looked up to him, because he wasn't scared of anybody. He was like a character out of *Boyz 'N the Hood*. When I look at that movie now, I'm like "Damn! That was my brother!"

He would get into trouble on purpose, I think to try to make my mom and dad kick him out. He was rebelling against being there. Sometimes they would put him out, but then he'd come back again and again. They just kept tolerating him. He didn't care about what my dad was doing. He was about being a gangsta. That goes to show you how powerful that gang life is and how it has the ability to shape so many kids.

When I think back on the ups and downs we've gone through as a family, there are things that make me happy and there are things that make me sad. That just comes with the territory. The important thing is to work stuff through. I'm still working through things with my family, but the good thing is that we all love one another.

You get older and realize how lucky you are to have family. That's why I say, make the effort to meet somebody halfway or let things go. Tomorrow is not promised.

CHAPTER TWO The Apple Don't Fall:
FATHERS . . . SONS . . .
BROTHERS

The apple don't fall too far from the tree

'cause I'm just like you and you're just like me . . .

—"The Apple Don't Fall,"
M. Sephus, E. Banks,
G. Levert /Gerald & Eddie Levert,
Father & Son

CLEVELAND, OHIO
MARCH 2, 2006
HOME OF GERALD LEVERT
EDDIE, GERALD, AND SEAN

The old saying "blood is thicker than water" may sound cliché, but it represents everything the Leverts stand on. Ironically, the group LeVert's first album was entitled *Bloodline,* and from 1986 through 1993 they had five back-to-back hit records. In the formal living room of Gerald's sprawling home there is an adjoining "Award Room."

The walls are lined with platinum and gold records and framed accolades that chronicle the LeVert run as well as Gerald's solo career and a two-album stint with

LSG (Levert, Sweat, and Gill). It all reflects the triumphs and strengths of that very special Levert bloodline.

Gerald has enjoyed tremendous success as a singer, songwriter, and producer. Meanwhile, Sean's career as a solo artist has not. The music business is a tough place to be, even for a Levert. However, because music is such a family affair, Sean is either on the road touring or in the studio with Gerald and their dad.

Today it's all about spending some quality father-son time. Eddie, Gerald, and Sean are lounging in the family room. Sean shoots Gerald a slightly crooked smile, another obvious Eddie Levert trait, proof positive that Gerald's lyrics and the old sayin' are right on the money: *The apple don't fall too far from the tree.*

"Yo, G, look at this, man!" Sean says, picking up a framed photo of LeVert, circa 1988. He finds a cozy spot on the plush sofa. Gerald is stretched out on the opposite end. Eddie sits across from them in a nearby chair.

In the picture, the trio, Gerald, Sean, and childhood friend Marc Gordon, is giving that very *Miami Vice*-meets-'hood-cool late-eighties vibe, complete with s-curls. Marc is the fly-guy with the Gazelle shades, flashing a small gold chain. Sean has that cute-boy-next-door vibe, and Gerald is the debonair ladies' man. "Those were some days!" Gerald fondly recalls.

When LeVert blew up the airwaves in the late eighties, their syncopated, expertly choreographed moves wowed thousands of screaming crowds. Their dance steps had evolved from The O'Jays' smooth two-step, mixed with a little Funky Chicken, into the Cabbage Patch and the Running Man. "Back then brothas didn't need all the bling and flash. It was about the voices and being cool, and LeVert was the complete package," Gerald says.

"We gotta do it again, G!" Sean exclaims. They give each other a pound.

Gerald leans forward, placing a hand under his chin. He narrows his eyes. There are so many deep and intricate layers to Gerald Levert behind that irresistible smile. This is yet another layer he is about to peel away. "Lately I've been thinking a lot about the future of my work, Dad's, your solo project, Sean, and even LeVert getting back together.

"There was a time when The O'Jays were at a low. But their career has come back to life. I think I've really just started to get to someplace great in my career. I'm old enough to know better, and I'm young enough to go farther." He pauses, clears his throat and speaks clearly, eyes focused. "I've always wanted Sean to have great success, too, and I know it's coming." The brothers give each other another love-filled pound.

"I'm proud that you and Sean have such a unique relationship." Eddie's voice quivers with emotion. "The fact that you guys and Kandi grew up together in the same household is a big reason. I hate that my other children didn't have the opportunity to grow up with siblings. I also think what you guys have is special because you've had a group together, sung onstage, and recorded together. Your connection as brothers is deeper than most people in this world are ever lucky enough to experience!"

Eddie is the proud papa in this tale of two brothers. Of the two Levert musical legacy heirs, the second crowned Levert prince, Sean, is a bit more low-key. Even the way he enters a room is more subdued. But when you see him perform onstage with Eddie and Gerald, that Levert thang comes out, and you know it's in the genes.

Gerald and Sean are very close, and like any big brother,

Gerald is extremely protective of him. Sean speaks with the same intensity when it comes to Gerald. One thing is for sure . . . they have an unbreakable bond.

Eddie

From my parents' marriage they had three kids: me, my brother Tommy, we called him Buddy, and my brother Andrew. I was the middle child. My mother later remarried and so did my father. She had three more children, Reggie, Justine, and Renee. My father had three more children, too, Frankie, Clifford, and Kelley. Clifford was the youngest, but he died.

I guess I had dealings with sibling rivalry, mainly when I first started getting famous. But after a while, it went away, since there was no one else in the family singing. I think they just felt like I thought I was hot stuff, or that I was trying to run things, because I was a big singer.

As a father I love all my kids the same, but I do understand that they each have different needs. I think I've always encouraged each of my kids to find their own personalities. I did everything I could to help them each realize their own paths in life. I figured out many years ago that if you have more than one child, love your kids equally, but *uniquely*. For example, my youngest brother Reggie stayed in trouble; he never wanted to go to school.

My mom was always more patient, giving, and nurturing with him even when he didn't deserve it. He didn't want to go to school or he'd act up. I'd say, "Mom, how can you keep doing this? What about me? Don't I deserve some of the time and effort you put into Reggie?" She'd tell me, "He needs me and

you don't. You're fine." I was confused for a long time, then those few simple words made sense when I had my own kids.

I know Gerald probably goes through a lot more with his siblings than I ever had to with mine. I honestly think that there's been some rivalry amongst him and his siblings, too. But in families, sometimes it's hard to avoid sibling rivalry when one child is more successful than the others. It's far different than my circumstance. What I do understand is that when you're in the position that he and I have been in as the leaders in our family, everybody thinks that they got the idea that they can make it work better.

What they don't realize is that it's about your work ethic and about who's gonna take the initiative to make the mistakes or maybe be wrong. When that happens, you have to be ready and willing to go and pick yourself up. Then you might just go and make some more mistakes, but you keep picking yourself up until you get it right.

It's about the guy who's able to take the controls and keep the train going on the same track, being able to keep the structure and take it to the next level, and that's why Gerald has the baton, he's that child. It's not because everybody sat around the family table and voted him to be the one.

Gerald

Sometimes there's jealousy within the family because there are those who say "I should've been the one, not him" or "He's not better than me." But the truth of the matter is, I never asked to be a lead singer, or the son that everybody came to for advice or a loan. The only thing I ever asked for was to be

successful and do something positive with my life. Technically, I'm the middle son, not the oldest. Most people think I am, though, because they may not know about Eddie Jr. However, I'm always viewed as my dad's oldest son because I'm the first-born in *our* family.

So, I really don't like the term "sibling rivalry," but I guess I've experienced some aspect of it, but more from a professional standpoint. Maybe my brother Sean has had desires to have a solo career comparable to mine. He's incredibly talented, so I know it's frustrating for him. My sister Kandi has never wanted to do the music thing, and we don't have those issues. If anything, admittedly, my tendency to be a little stubborn is probably where we clash.

On the flip side, I think about the lifestyle they both have. Kandi is married with two kids and has one more on the way. Sean's married with two sons. He has two sons and two daughters from previous relationships. I know being married is not easy, but it would be nice. I'm ready. Life is funny; even in families you can find yourself thinking that at times the grass is greener.

The one thing that I don't ever want to feel is that I have to be defensive about what I've worked hard to acquire. Making music is an extension of who I am, Gerald Levert, and what I've always wanted to do. With success and money you can buy all the latest fashions, or cars, or homes, but materialistic things don't make the man. I haven't changed or become grandiose.

Anyone who doesn't know that doesn't know me, family included. So accept it and be supportive. I'm still me. You have to respect that. I've worked hard. I don't do anything in this business for selfish reasons. I want us all to be successful!

Sean

In terms of sibling issues, or some folks might say sibling rivalry, we're no different from any other family. We have arguments, and good days as well as bad days. But when you're in the spotlight like us, sometimes you have to deal with a lot of rumors and speculations. It comes with the territory. Since me and Gerald were in a group together *and* we're brothers, I think the public tried to come up with all kinds of stuff to say about our relationship when Levert broke up.

Some people said it was because the group had creative differences. Some even said Gerald betrayed the group in favor of a solo career. He didn't betray anybody! It's true that Marc and Gerald grew apart creatively. To be honest they fell out bad, but they've since reconciled. It was also about the record company pushing for Gerald to be on his own.

But Gerald's solo career wasn't a surprise. I just felt he could've told us sooner than he did. That made me a little mad, but groups breaking up have happened all through musical group history. Look at The Supremes, The Jacksons, Bobby Brown and New Edition, and even Beyoncé and Destiny's Child. My dad's group is probably one of the last groups from his era still together.

I always felt LeVert would be back. Truth is, we never left. I've still been touring, recording, and performing with my brother and my dad. My brother has always looked out for my best interests. I also have to be honest that I've been waiting for and wanting my turn as a solo artist for a long time. That's what I'm working on now.

Whatever you want, whatever you need

I'm here for you, yeah

There's never too much that you could ask for

I know it's gonna be cool

I do it for the love . . .

> —"For the Love," G. Levert, E. Nicholas /
> Gerald & Eddie Levert, *Father & Son*

Gerald

Sean was recently recording a record in the studio and he has a song with the lyrics, "I'm just me and not my dad, not my brother . . ." I was upset about it, and when my dad heard it, he got upset about it. You can't just distance us. There are always going to be comparisons. I had to go through that. I had to go through building my own brand. And that's something you can't just go up to people and say, "Well, I'm not Gerald, I'm not Eddie." That's something you should be proud of!

Maybe it is a sign of him getting some of the things he felt off his chest. But it hit me in a strange way. I took it as more of a sign of jealousy. I just feel like people don't want to hear that.

My thing is for him to understand that everybody gets to eat off what I'm doing and what my dad is doing. Moreover, with me and Dad, the more I'm doing, Sean's going to be a part of it, and the more Dad's doing, he's going to be in some way a part of that.

Sean

I wasn't trying to diss Gerald and my dad when I wrote the song. I was speaking what I feel in my heart.

In the beginning, me and Gerald were both hungry to have our own identity. With me, it's always been harder because Gerald got his identity from my father first. Now I have to get it from him and my father. I wish Gerald and I could come together and work on my solo project. I need his help. However, it's hard to get Gerald to focus on doing anything other than his own music right now. He has his next CD to think about. He wants a big record, of course. It gets a little frustrating.

When we were together as LeVert, we had back-to-back hits. Gerald as a solo artist has had some great records, but not those big, big back-to-back records since the LeVert success. A lot of people don't know that Gerald wrote all of those LeVert songs before going solo. He writes all of his own songs, and he's gotten even more acclaim for the songs he's written for people like Barry White.

I really wanna do another LeVert album, but it would be on Gerald. I'm letting it go for now. Anyone who knows Gerald knows that he's very strong-minded. Pressing him to do or talk about something never works. The timing has to be right. I will say I'm probably the only person who will really talk to Gerald straight up, and honest.

Not too many will do that, just me and my dad. Everybody else in the family, or close friends, is afraid they'll lose their job. My brother has a good heart, but he's also the type that'll get mad quick and then he'll want to cut folks off. He can be a little hardheaded.

It's all good, though. I'll always be Eddie's son and Gerald's brother, but the most important thing is, we're gonna always be family. This music ain't gonna never change our love for each

other. We can argue about the tours, or the lyrics in a song, but we're gonna be there for each other after the hit songs.

Gerald

I hear it every day and my dad hears it, too. People say, "I grew up on Eddie, I like Eddie better than I like you," or "You're Gerald's father? I like Gerald better than I like you!" So we all have to hear that. Not to say Sean meant any harm with the song he wrote, but for him to go and spend time writing a song and producing it, to me, was kind of like putting down our relationship. That affected me.

For a long time I hated to be in my father's footsteps, too. At first there were a lot of comparisons, but it just made me work harder, and that's what the comparisons should do for Sean. You don't have to put it out there in the streets that you're not Gerald and you're not Eddie.

People know I'm not Eddie! Be creative enough to separate yourself from us. And don't take it like we're trying to take something away from you. I would love to see all my siblings be successful at what they do.

My brother Sean didn't want to be in the music business at first, but I pulled him in. I guess somehow I feel responsible, and when I hear something like a song like that, it hurts my feelings. I didn't mean to pull him into something and have it not pan out the way he wanted it to. I told the record company when I first got my solo deal that I wasn't leaving my brother behind. He's very important to me.

My relationship with Sean is clear. He will always be a part of what I do! What he expressed in the song he wrote was

what was in his heart. I can't fault him for that. If we discuss it, fuss about it, that's okay, too. Like Sean said, it's all a part of being a family. Everybody can't be the most successful one. Even if you put in the work, it doesn't mean that success is guaranteed.

Look at the Jacksons. You got Michael and Janet, but the rest of them eat. When Michael went to court, I thought it was great that they were all there. When the chips were down, they came together. That's what I mean by being family. And even when you don't agree, be there for the family. Don't be mad about it. Just help where you can help.

My sister Kandi has a beautiful voice, but she didn't want to sing. She has a family now. She's a sensitive person and is working on getting involved in helping people in the community. She enjoys having a family and keeping them together. Somebody out of all of us needs to do something right! She's a great example. I love to see her happy about that. I've done some albums and had her sing on them, but people would never know it was her. She doesn't want to be known like that.

My point is that some folks don't want to play the back and just get the money. I wish I would've played the back and gotten the money. It becomes really stressful at times, because you can't walk around freely when people know your face everywhere you go. I wasn't prepared for that and all the things that came with being successful.

Sean

I don't think any of us were necessarily prepared for the level of fame LeVert achieved. Marc wasn't, and I definitely

wasn't. Even though Gerald was just as green, I'd have to say he was the most prepared, although he says he wasn't. The difference between us and him is that music is what Gerald wanted to do from a baby. I got into music *because* of Gerald. He was my only big brother and the only person I had to play with. He always wanted to sing, not go out and play basketball or football like other kids normally wanted to do. All he wanted to do was make music.

When Gerald and I were teenagers, he started LeVert with his best friend, Marc Gordon. It started out as an actual band. They used to rehearse at our house. The drummer used to leave his drums at our house. One day I just started playing the drums. Eventually, I got better and better and ended up in the group.

LeVert had about nine members at the time, but once me, Marc, and Gerald started figuring out how many different ways the money would have to be split, we chopped it down to just the three of us. By this time I was about fifteen and Gerald was seventeen. We didn't have a record deal, but we were doing local shows. I would switch off and come up front and sing some songs and then go to the back and play the drums.

Most of the songs we sang were top forty. Back then on the club circuit you had to do three sets of about forty-five minutes. To fill up the time we had to learn about fifty songs. The beginning was great, and the most fun for me. It turned into real work once we got the record deal, and that's when it stopped being fun.

Getting the record deal was huge. I was sixteen, Gerald was eighteen, Marc was twenty, and everybody around us was much older. I felt like we were thrown into mature situations at every

turn. It actually became overwhelming. Basically, in the entertainment business you grow up fast. Believe it when they say it's all about sex, drugs, and rock & roll. When you're hanging with an older crowd, they give you what you want to make you happy. There was a lot of temptation. That's what I remember most about coming into the game.

Gerald's work ethic was intense. There was always conflict between us when we would be recording in the studio. He would get mad and holler at me, because he expected more out of me than I was giving. It all goes back to the fact that at the time, making music wasn't something I was ready to do. I didn't know what I wanted to do. I was thrown into the group thing by him, and I was more into partying.

Gerald would be in the studio working and I would tell him, "Hey, I'll be out kickin' it! Call me when you need me to lay my vocals." That would make him furious. We fought and then we'd get back to work. Ultimately, I think the intensity and our fighting brought more out of me vocally than I ever imagined. When we played the finished record, I could hear how good it was and I understood why he was pushing me. It was a learning experience.

Unfortunately, I fell into the drug thing for a while. I started just coming to the studio when I had to. I spent more and more of my time hanging out. For the most part, I was the party man during many of the LeVert years. People knew they were going to get their party on if they got with me. I was like that almost until the last record we made together.

My mom was my motivation once I made up my mind to get myself together. She kept us very grounded growing up

because of her religious beliefs. I knew what I was doing was not only affecting Gerald and my dad, but it was affecting her, and I couldn't disappoint her. Gerald was very supportive.

Gerald was my big brother, but he was also more like a father figure because we were around each other all the time. My dad couldn't say a lot because when The O'Jays were in their heyday, he used to party hard, too. However, he was stronger than I was when it came to dealing with the same temptations.

My dad could stop doing the drinking and dabbling in drugs on his own. He knew his limits and never let it get in the way of his work. He never took it over the edge. I commend my father for cleaning up his act. It's very hard to do that on your own. He didn't mess up, and guess what? He's still Eddie Levert!

When it came down to it, Gerald and my dad could give me their opinions, or even tell me what to do, but I wasn't going to get help until I was ready. A person has to make up his own mind that it's time to take action and take responsibility for his actions; until then, that person isn't going to do anything about his problem.

I loved my dad then as much as I love him now, but I didn't have the same relationship with him as I did with Gerald. Luckily, I was young when I made those mistakes, and now I have a second chance.

I think now that Gerald and I are both fathers ourselves, we made the decision to raise our children differently than how we were raised. We didn't have to talk about it. Because my dad didn't have the time to spend with us when we were young, even as recording artists, we weren't gonna go in that direction.

In my dad's defense, back then The O'Jays would be gone several months to a year recording in Philadelphia. Then, by the time their record was done, their tour would start. Once LeVert came along, there were studios in Cleveland so we could record at home.

In those days the concert tours were different, too. Tours were a year long. Groups worked nonstop. Right now you can't find a concert tour longer than ten or twelve weeks. You'd be lucky to get eight!

We didn't have a chance to really see our dad. He didn't sit us down to talk about the birds and bees. We figured it out on our own. Unfortunately, a lot of what I learned was from the older people we were around in the entertainment business. That's no way for a kid to learn, but that was the case.

I think the celebrity lifestyle, the lack of knowledge, and not having that constant presence of a father had a lot to do with both me and Gerald's lack of responsibility in terms of having kids without being married. For example, we didn't have someone telling us to use a condom. With my kids I'm teaching them about those things.

In terms of life lessons, our dad was the type of cat who let you figure it out on your own. I can better understand him now than I could when I was younger because I'm in the business.

You bring me up when I'm down
I know that you'll be around
When everything's going wrong . . .
—"I Got You," G. Levert, E. Nicholas, P. Gibson, D. Spencer /
Gerald & Eddie Levert, *Father & Son*

Eddie

You can't build success alone. You've got to have the support and involvement of family to help you get to where you want to go. Someone's got to believe it with you! Having the support of your father is the most important thing. I think that fathers have to take that position to lead their kids into certain situations that are best for them. Not necessarily to tell that child *what* to do or be, but to give them some direction of how to go about getting what they want in life, and talk to them about the strong work ethic you have to use to get there.

I look at my son, Gerald, and I admire him. He's one of the hardest workers I know. He's earned everything he's gotten in life. It wasn't a gift. Yeah, his dad was a famous singer, was in the business, and was able to open doors, but once the doors got open, he went in and took care of his own business and he got it done. I'm so proud of him!

When you have more than one kid, you find yourself balancing their different personalities. You have to be different in the way you approach each one as far as discipline and communication. Sean and Kandi are very sound people. They are more independent emotionally. We don't have to really talk, but I know they're fine.

Sean's my easiest child to get along with because he listens, he takes it in. He uses whatever part of it that works for him. He doesn't take it as law or me passing judgment. Kandi does her own thing. She asks me for advice and when I give it to her, she'll use it, but she does so at her own pace.

With Gerald, I have to be a lot more tactful because he's a hothead, and if I rile him, we won't get anything done. All we'll

do is end up in an argument. If you sound like you're talking down to Gerald, then you may as well chalk it up, there's no need in trying to discuss anything else. Gerald is passionate, very emotional.

His brain is always working overtime and he's the kind who has to talk things through. He can be stubborn, and I have to use a lot of patience to help him work through that stubbornness. I think it's important to be your own man, make your own choices, then you've gotta be prepared to live with those choices in the end.

I've learned how to deal with all of them to keep from ending up in a big, heated argument. I don't love one any more or less than the others.

Gerald, Sean, and I work together. I am their father, but I want them to know that I can be selfish, and I can be destructive, and I can be sad, and I can be lonely, and all of that. And sometimes I have to speak to you as that person. At some time, I, as the father, have to reveal to my sons that I'm a person who cries, hurts, feels bad, and has bad days.

When that happens, I'm not speaking to them as their *father*, I'm speaking to them as a *person*. And I think that makes for a better relationship.

Y ou're my Darlin', Darlin' Baby

You're my sweet and tender love

—"Darlin' Darlin' Baby
(Sweet, Tender, Love),"
K. Gamble / L. Huff,
1976 #1 R&B single,
The O'Jays, *Message in Our Music*

CLEVELAND, OHIO
APRIL 17, 2006
HOME OF KANDICE LEVERT BROOKS

Gerald holds up an old Polaroid. Its edges are tattered and worn, but the image is almost perfectly intact. A few faint, hairlike scratches give it character. The photo is dated January 1968. In it, Martha and Eddie Levert are decked out to the nines, ready for a night out on the town, smiling like two blissful lovebirds. His arm is draped around her shapely shoulder.

"Mom was beautiful," Gerald admiringly notes. Kandice Brooks (Kandi, as she is affectionately called) sits next to him and nods in agreement. Gerald glances over at her. "You takin' care of yourself, right?"

he asks in a fatherly tone. Gerald nods toward her stomach. She rubs her round belly, "Yes, Gerald, I'm fine!" Kandi rolls her eyes in exasperation. Kandi is glowing and in the early months of pregnancy with her third child.

Gerald shifts his attention back to the photo. "Mom was sharp, wasn't she?" He excitedly points out the designer-styled minidress Martha is wearing, trimmed with white ruffles. "Dad's suit was fly! You had to be a bad-ass dude back then to put on a pink dress shirt and cuff links! Ha, ha! He was clean."

Kandi pulls out another photograph, a black-and-white portrait of Martha as a teenager. Her flawless cocoa skin and natural makeup-free state could've easily made her a candidate for one of those old beauty creme ads. Gerald brushes his large, powerful fingers gently over the photo. "She's like an angel. Maybe that's what makes it hard on some of the other women in my life. I expect them to be on Mom's level. That's probably not very realistic. She's strong, though. She took a lot of stuff from Dad. I mean it was never physical abuse, but it was a lot raising kids when he was out on the road."

"I think when he became a father, he wasn't ready," Kandi adds.

Then, as if on cue, Martha Levert enters holding what appears to be a large lime green binder. If you ever want to see Gerald Levert blush, just let Ms. Martha Levert enter a room. His face lights up like a five-year-old's at an amusement park, just like now. She is the number one woman in Gerald's life. Close friends and family simply call her Marty.

Martha walks with an easy glide, and as easy as her stride is, so is she on the eye. She's petite, round, and soft, and exudes the spirit and resilience of a woman six feet tall. Martha's face

has a youthful radiance for a woman who's raised three grown children—Gerald, Sean, and Kandi. Pieces of her are in each one of them.

Gerald immediately rushes over to hug his mother. "You feel okay?" he meekly asks. He is no longer Gerald the superstar-platinum recording artist who makes grown women scream and fall out when he rolls around onstage during his shows. He's just Gerald, her baby. There is strength in her slightly weathered eyes. This relationship between a son and his mother is precious.

She notices her old picture in his hands. "Ooh, I was so young!" Martha's dark brown hair shines under the light, which picks up tints of red and light brown in it. "I think I was in high school. Probably around the time I met your dad. He was always hangin' around my school. Shoot, I don't even know if he was *actually* in high school. He was just always there. I think he begged and followed me around so much until I gave in and he got me to marry him in 1965. Gerald, you were born a year later." She wistfully reminisces. Gerald and Kandi are hanging on to her every word. Martha hands Gerald the big, bright green binder she's been holding. It's a scrapbook of old photos and press clippings from The O'Jays' early years.

Gerald opens the scrapbook, flips through the delicate pages, and points to the captions written under each photo or magazine clipping in Martha's handwriting: I AM STARTING TO GET DOWN! LOOKING GOOD FELLOWS! KEEP SOCKING IT TO THEM, NOW THAT YOU ARE THERE! UP, UP, UP AND AWAY, IT'S GONE! SO WATCH OUT FOR THE "BACK STABBERS" YOU DIRTY DOG!

Gerald being the constant jokester mimics her, reciting one of the longer inscriptions. "Baby, I can't stand it. In a minute

you'll be too important to own. But I like it. So hang in there, fellows, 'cause you are looking good, good, good, and I mean very good!" Martha playfully swats Gerald. She flashes a bashful, girlish grin and for a moment that old black-and-white image of her as a teen comes to life.

Gerald eagerly turns another page. Martha frowns, "Be careful." She reprimands and he retreats, turning into little chubby-cheeked Gerald.

Kandi interrupts, pulling yet another photograph from a small stack of loose pictures. Gerald's eyes land on a snapshot of her in cap and gown from her college graduation from Cleveland State. She is standing between Martha and Eddie. She bursts into laughter. "Don't you remember this?" Gerald throws her a confused look. She can barely contain herself. "Just about an hour before the graduation started, I was driving to the college in your Range Rover.

"Mom and Dad were already there waiting for me. I had the music going and all of a sudden I ran a light and a car slammed into me, then I hit a pole! It was awful. I tore up your car. I was banged up pretty badly, too, but I was more worried about what you were going to say when you found out. You weren't there because you had an LSG show.

"I just knew I had to get to graduation or Mom and Dad were gonna kill me." She gives a female version of that famous hearty Levert laugh. "I called one of our cousins and he helped me get the car towed and make it to the ceremony on time. All I could think about was, this was my second time wrecking one of Gerald's cars!" She is laughing uncontrollably at this point, and Gerald and Martha join in. Each time she tries to stop laughing, Gerald or Martha starts up again.

"When this picture was taken, Dad had hugged me really tight and it hurt so bad! I was in so much pain from my cuts and bruises. No one could see them because of my graduation robe. After they snapped the photo, I broke down into tears, then I confessed to Dad. He was really supportive and encouraged me to tell you. It was like he knew you would go easy on me."

"I did, too! I remember. The first thing I asked was if you were okay," Gerald says. The laughter erupts all over again. "Yep, but right then and there I made a vow to never drive any of your cars again. I figured they were bad luck!" The laughter lingers a few more moments, and then Kandi picks up a photo of Eddie with their five-year-old sister Ryan on his lap. She's the newest edition to Eddie Levert's family tree.

Kandi's two daughters, eight-year-old Kennedy and four-year-old Logan, sit on opposite sides of Ryan and Eddie, the jovial dad and Pop Pop, as he's called by his grandkids. She stares at the photo for a long time. Her joyful expression slowly turns to one of melancholy. Gerald puts his arm around her. "You've always had a special place in Dad's heart. You know that, right?" Gerald says reassuringly.

"I know, but we have a strange relationship." She lets out a sigh. "As a kid you don't see things as you do as an adult. Like when Dad comes to town sometimes, I'll find out after the fact. That's just one example." Her jaw tightens. "I've grown to accept it, though." She sighs again. A tiny row of wrinkles forms between her eyebrows and her voice shakes. "It used to really hurt me when I was younger. I would call him and the first thing he'd say was, 'How much money do you want?' Not, 'How are you?'"

At thirty-two, Kandi has a family of her own. She is a grown woman by all standards, but there is a bittersweet innocence to her demeanor as she examines her father's face in the picture more closely. "Now, since I've gotten older, I've made it a point to always be there when it comes to my own children. I don't want them to ever feel like I did."

She lowers her eyes. "Dad says I make him nervous. I don't understand because I'm his child. I know he feels bad for the way he and my mom broke up. Maybe when he looks at me, I remind him of that. Maybe that's what makes him nervous. You, Dad, and Sean connect with music. With me, you have to have something else. I never felt like I was missing anything in terms of not being in the music business."

"You've seen it all, the behind-the-scenes stuff and the stress, because of *us!*" Gerald emphasizes.

"I love him to death." Her eyes narrow. "I just wish that he could see that we could have a normal father-and-daughter relationship. I don't want anything from him but his love and respect. I want him to call me sometimes, just to say hello. He doesn't see my daughters that much. He sends money. That's his way of showing affection. I guess that's the only way he knows how," she says with a raised eyebrow.

"In his own way, Dad is a great person. I really do love to sit and talk with him when he's just my dad, not Eddie Levert of The O'Jays." She chuckles and her face suddenly ignites with an exuberant smile. "Every once in a while he gives me a glimpse of who the real Eddie is. I would like more of that." The innocence that you find in both Gerald and Sean's eyes is in Kandi's, too.

As a father who's had a successful career in music, Eddie's been a good provider for his kids. Perhaps not in the traditional sense, but his children have been afforded a lifestyle and exposure that most folk never get an opportunity to experience. What is even more commendable is that neither Eddie nor Gerald turns a blind eye to his faults.

Eddie

I wish I were closer to my daughters, especially Kandi, because she's the oldest girl. My firstborn daughter. When a father has a daughter, that bond is just as sacred as a mother's with her son. If that sacred bond is broken or nonexistent, then that young girl can be set up for one unhealthy relationship after the other, always searching for that father figure.

A young girl's first connection to men is with her father, and she learns first from her father how a man should treat her. Daughters are our future nurturers! Kandi has indeed become a nurturer and is a good mother.

She has a wonderful family, and I'm glad she has a good husband. Her brothers and I were gonna see to that. They knew to look out for her when I wasn't able to be around. Do I think I could've been a better example as a husband in terms of my duties and being in the household? Sure, but through their mom, Gerald, Sean, and Kandi were able to see the good side of me as a dad.

It's funny, all of my daughters, Kandi, Asha, Uri, and Ryan, think that I'm more into the boys than the girls. It's not that I'm into the boys more, it's just that I understand them a little bit

better. With Kandi being the oldest, she's my worst critic! She won't give me an inch. But she's learned how to let me off the hook now, and I've learned how to live with my daughters, to try to understand them a little bit more.

I love my daughters unconditionally; there's nothing I wouldn't do for them. They are precious and invaluable to me. But let me get this off my chest from the jump . . . they are also some of the most complicated people in my life. Me and my daughters have a love-hate relationship. It's like they put up with me. They tolerate me. I know that Kandi feels sometimes like, "Hey, if he was my husband, I'd break his neck!"

Daughters have a tendency to want to tell fathers how to live their lives, how we should dress, where we should go, and what we should or shouldn't eat. My daughters are very opinionated people. What I try to do with them is love them from afar! They'll do anything for their dad, but they still want to direct traffic.

Daughters, no matter how old they get, still want to be daddy's little girl. Kandi has those moments where she wants to turn into the little girl; in fact, all of my other daughters do that, too. But Kandi won't let me try to flex my fatherhood. She will put me right in my place immediately. She'll say, "Hold on, hold on, you're my dad, but I'm still grown!" That's basically our relationship.

As far as making the choices and picking who my daughters want to be with, that's all on them. I have to separate myself from that and say, "Well, this is who she's chosen to be with." If she likes it, I love it. But I am not going to tolerate any dogging. I'm not going to tolerate any abuse. I'm not going to tolerate

any of that stuff 'cause me and her brothers will go see about all that!

But again, I feel that it's a personal choice a woman has to make for herself. My philosophy about parenting is to let children do their own thinking. That's how they have to learn. I won't get involved with saying things like, "He's not the man for you!" I'll ask my daughters, though, "Is this what you like?" or "Is this what you want?" If she says yes, then I think she should go about trying to make it work.

> Sometimes my ego gets in the way
> I don't say I love when I should say
> It ain't your fault I had a bad day
> For your happiness is why I pray . . .
> Your smile your face is all that it takes
> Is all that it takes to humble me . . .
> —"Humble Me," G. Levert, E. Nicholas / Gerald Levert,
> *Love & Consequences*

Gerald

Because my dad was gone so much, I guess when Kandi came along I was like a father to her a lot of the time. Me and Sean approved of her husband, Leonard. That probably made my dad comfortable when they were dating. We were protective, but he passed the test.

Every now and then I think about what kind of men my daughters will ultimately be with when they get older. With my son, Lemicah, I just want him to have a good woman in his life

one day. Carlysia and Camryn better have the best. All dads get like that with their girls, though. Boys are tougher. My biggest concern at this point is me having the best relationship I can with my kids.

Of my three kids, my son Lemicah has been around me more. He's seventeen, the same age as my oldest daughter Carlysia. My little girl, Camryn, is eight. I've spent a lot of time raising Lemicah. I hate that, because of the circumstances, I haven't had the opportunity to do that as much with my girls.

Carlysia lives in Atlanta and she wants to sing. We did an MTV special, *My Sweet Sixteen*. It was crazy! In hindsight I wish I had never given the party or appeared on MTV. MTV made it seem like I had spent two million dollars on the party, which I didn't. Nowhere near that! But I took a lot of flak from my other babies' mothers.

My point is that Carlysia wants to sing, and we've become a little closer because of that. She's very emotional about everything I say. I'm trying to show her that it's not as easy as she thinks it is, just because she's a Levert. That doesn't mean things are going to automatically happen for her. She's going to have to put in the same work that everybody else did. Sometimes it gets a little touchy.

I'm not going to settle for less than what I think she can do. And I think she could be really great if she works hard at it. If she's not willing to work hard, then I'm not willing to give her one hundred percent of my time. My father was that way with me.

This is now a part of our whole relationship. I know what Carlysia wants to do, and I know how she feels because I'm not

around all the time to help her start a singing career. In the meantime, until I can dedicate the time to groom her, I want her to work harder on her own to show me that she really wants to sing. I had to work hard and prove to my dad that I had the talent and stamina for the music business. It's not something that comes overnight.

Now my little girl, Camryn, I've yet to see what she wants to do. She's into everything. She wants to spend more time with me. But a lot of that has to do with my situation with her mother. When the parents' relationship is not great, the kids suffer, the parent who doesn't have custody suffers, and their relationship with the kid suffers.

That's basically what happened with me. My relationships with my kids have suffered. They've become somewhat like I used to be with my dad. They get frightened about everything I say. They also think everything I say is golden, and it's not. Like when my father would come home from the road and we would be in awe and watch him. He'd be like, "I'm not gonna get up and fly away!"

When you're not able to spend a lot of time with your children, you become some kind of phenomenon, because you come and go in their lives. It shouldn't be like that. You should be partners with your kids. You should be able to talk with them.

With me and my dad, there were a lot of times I was afraid to express myself. I see that with my kids. They feel like they have to be perfect because they're a Levert. They don't want to make the name look bad. Camryn is just figuring out what me and my dad do for a living. She sees now that her dad and her granddaddy are recognized by people.

We go together like birds in a tree
I'd be in a world of trouble, girl, if you wasn't here with me . . .
—"Forever Mine," K. Gamble, L. Huff / The O'Jays,
Identify Yourself, #4 R&B, 1979

Eddie

It took me until I got old to see a lot of things. I know better today than I did yesterday that as a father you have to spend as much time communicating as you can with your daughters. I can't stress that enough. Time and talking, it's all about nurturing.

A father can set the tone for every man that comes after you, and determine how she's going to grade every man that comes along. You can set the tone for whether she picks a thug or a good guy, the guy who's honorable and who's gonna do the right thing or not, or whether she goes with a bum. She'll always have you as that mirror to compare every man to.

Gerald

Be real with your kids; don't sugarcoat things. My dad may have had his faults, but the one thing he's always been is straight up with us. I appreciate that, and it's a philosophy I have with my kids. With my girls, even if it's about their period starting or safe sex, as a dad you have to be real about that stuff. Let your children know you know what kind of support they need in their lives. In my case, I try to be there for them when I can, and make time for them when I can. I can't stress that enough to brothas.

Even when things are bad between you and your kid's mom, don't ever talk bad about her, and make your children respect her. At the same time, make a pact with their mom to do the same as it relates to you.

In my situation, I have three different baby-mamas. I'm older and have done the fighting and arguing, and it took me a lot of years to see just how unfair it was for my kids. I can never put my past on Lemicah, or my girls, Carlysia and Camryn.

Do I wish I wouldn't have had sex until I was married? Hell yeah! But every brotha who may have had a kid out of wedlock or before they were ready could say that after the fact. The first time I had sex, it was like, damn! Like Lay's says, "You can't eat just one!" Seriously, I wish I'd have been more careful and would've waited. But realistically, I guess for me that wouldn't have been too easy, coming up in the eighties and singing love songs. I can't fathom that, not being with girls.

And now I feel bad because my kids are spread out in different places, and other men come into their lives, and you don't know who they are. A lot of things come into their lives that you aren't a part of, and you don't know anything about it.

You just become the person who supplies the money. The moms make all the decisions. You really don't have a whole lot to say in the end. If the moms have their minds set on doing something with the child, they're gonna do it. When the father isn't present in the home, what you say doesn't mean much.

I wish I would've been smarter. I guess there are a lot of things I wish I would've done differently now that I'm forty years old. But at the same time, I've enjoyed my life so far. I wouldn't change it, especially my kids. I love them. It's bad that their mothers have been able to take them away from me to

different cities. I get mad and wish there was a law. A woman shouldn't be able to just take the kids away from their father!

Their mother could tell you anything and then turn around and beat negative things into the kids' heads. The parent who spends the most time with the child has the best advantage. I have no advantage. It's like you have no control over your own life. My kids' mothers tell me how, what, and when things are going to happen.

My relationship with my mother has helped me with how I've worked through my baby-mama drama. But hey, let's be real, that's my mother and she's gonna be on my side, that's the way it goes. She's going to always be there for me.

My dad said one time, "A mother is always trying to save her child. If he's at the end of the rope and about to fall over the cliff, she still feels like there's something she can do. She's gonna try to pull him back and he will come back to her. Gerald and his mom are thick as thieves!"

I do think that deep down in her heart she wishes that I would've been more careful and more responsible. She taught me better than that. I could never blame what I've done on her.

I remember one of my baby's mamas said to her, "Your son is out here doing this and that, and you don't have any control over him!" That has nothing to do with my mother. The things that I've done or that any of my siblings have done have nothing to do with my mother. Whatever we did, we did it because we wanted to. We knew what was right or wrong because my mother taught us that.

I have been so mad at one of my kids' moms that I wanted in my head to do something negative, but I thought about my mother, and that was enough to not hurt a female. Let me be

clear, I would never hit a woman, but I was angry and frustrated. My mother talked to me and told me that I couldn't do anything crazy. I had to think of my child. My mother helped me see that the real reason my child's mother may have said mean things was because she wanted me to be with her. She was right.

My point is that I'm just trying to be all I can to get my kids to the next level in life and make them understand that I'm trying to be a better person as I grow older and be more a part of their lives. I want my daughters to have a good relationship with me so that when they're grown they have me as a positive example when they choose a husband.

It's different when you're a man who has girls. I see that Lemicah and I have a relationship like me and my dad. Carlysia is going to be an adult in a few years. I want her to know that a man should always treat her with respect and love. Camryn is still young, thankfully. I've got a long time to get ready before she starts dating and all that!

Sometimes I just wanna throw up my hands
But that's not the real manly thing to do
Sometimes I just wanna give up and quit
To hell with it
What about my child?
No matter how hard I try to do right
I can't win for losing
My heart means well but I always fail
I can't win for losing . . .
 —"Can't Win," G. Levert, E. Nicholas /
 Gerald Levert, *Gerald's World*

Eddie

I guess I can relate to what Gerald's saying about his baby-mama drama. My generation didn't quite call it that, but yeah I've experienced it. I have seven kids. I own up to the fact that I've made my own choices and had to live with them. I may not like what I've done in the past, but I love each of my children.

Any man who has a baby should take care of that baby. And don't get mad because the mama wanna put drama on you! Remember, you didn't have to lay down with her. You've got to look in the mirror and know that you brought those things on yourself, and you can't blame women. Women are sensitive. Face it, they're gonna read you the riot act when they've been done wrong.

I've lived enough life and had to take some hard lessons, and I feel like I'm qualified to tell other men out here to think about what you're about to do before you do it. I could've used my head better in the past. But being a father is a great, great thing. I can appreciate it in my old age.

I look at my life and say: Hey, all of these kids are a part of me and a part of their moms. Now when they do bad things, I question what part of me that was, and vice versa. It's very easy for us as parents to take the bows for the good things, but who takes the credit for the bad things? I have to take credit for both.

There's also a young lady named Shaunquetta. About fifteen years ago she showed up in Las Vegas while The 'Jays were rehearsing, claiming that I was her father. Now, we've never done a paternity and I don't remember ever knowing her mom.

She's been such a kindhearted, classy, and graceful person, I don't mind her saying that I'm her dad. I'm glad to have her. She's never created any problems or done anything to me and my family. We've all embraced her, and I've got love for her.

I've been a big star for many many years, and as I always say, that's not an excuse to go out and have a lot of kids, but you never know what goes on in life. Back in the day, I was loose on tour, we sold out concerts, and we did a lot of partying.

I'm at the stage in life where I have grandkids older than my youngest daughter Ryan. Now I'm settled, happy, and focused on my family. I know what Ryan needs as she grows as a girl into womanhood, and I can be there for her. I'm also working on opening myself up to my other daughters. I got to believe it's never too late.

Gerald

With my kids, there are different mothers telling each child a different thing. One might say to one of my daughters, "Your sister has this," or "Your brother has that, and you need to have that, too!" Basically, now it's like a competition or something between my other children's mothers about what I should be doing for their kids.

I completely agree with the way my father used to handle all of us. He was always of the thinking that if one got one thing, then everybody got the same thing. That's how I feel now. The challenge just always becomes that each of my children's mothers has her own agenda.

As fathers, we need to tell the truth to ourselves. Are we doing all we need to do to be good fathers? For those of us who

have daughters, remember that what they see us do and say affects what kind of men they're drawn to. When you're out there in the street talkin' about "pimpin'" and calling women "bitches," you should think about your daughter, or the fact that a woman gave birth to you. Check yourself and show a sista some respect!

PART TWO

Community and Spirituality

As black people, it's time to recognize our power. We need to take examples from the days of marching in the streets! It's time we get back to the foundations of our community: prayer and faith!

—Gerald Levert

People all over the world, join hands

Start a love train, love train

—"Love Train,"
K. Gamble, L. Huff / The O'Jays,
1973, #1 R&B, #1 Pop

LOS ANGELES, CALIFORNIA
MAY 12, 2006
WYNDHAM BEL AGE HOTEL

"The O'Jays' music has always been a platform for people to deal with social and political issues that directly affect the black community," Eddie says, peering out at the garden of the Bel Age Hotel dining room. Gerald is fresh from the barbershop, sporting a cream-colored warm-up suit and crisp white sneakers. Eddie is dressed similarly, but wearing blue warm-ups. He doesn't look like a man in his mid-sixties, but his knowledge and experience are proof enough.

"When you listen to The O'Jays' songs, you're more often than not listening to a political science lesson on wax," Gerald says.

"Gerald has always addressed his views and thoughts on the same things. We've never been afraid to send out an urgent message of love and hope. I'm neither a politician nor a preacher," Eddie proclaims with a slight smirk.

"But that doesn't mean we're not affected by what's happening in our communities around the country. We are, just like millions of other black men and women," Gerald says, nodding toward Eddie. "It's about coming together. It's time for us to stand up for us."

Eddie is especially passionate when he speaks of politics in our society. The songs The O'Jays gave us, such as "Give the People What They Want," "Survival," and "Love Train," are symbolic of reflecting the importance and necessity of a "Love Train" for the twenty-first century. In Gerald's most prolific and critically acclaimed record, *Do I Speak for the World,* he recaptured the spirit of the The O'Jays' sociopolitical meditations that dominated the radio airwaves in the seventies.

On the album, Gerald challenges the government on topics ranging from terrorism and the war in Iraq to same-sex marriage and unemployment. "A lot of people are pained over what's going on in our world. It's not black or white or rich or poor, it's a people thing. I wanted the record to be a voice for the voiceless, old and young. I wanted to put it all out on Front Street. We can't be timid or scared to question the powers that be in this country."

"Everything from the Bible is coming to pass. The same civil rights we fought for during the days of Dr. King are still issues today. Katrina was proof that despite our many accomplishments as black people and people of color, we are still living in the struggle. Don't you think it's time we stood up

for our brothers and sisters living below the poverty line?"
Eddie adds.

Eddie and Gerald have never been timid or scared to speak
freely about life, love, religion, and politics. This father and
son's music has never held back and constantly pushes for
change.

Eddie

Where I came from, Canton, Ohio, to here, is a very long
way. It's like I busted out of a place that a lot of people don't
ever get away from. There are a lot of people still there who are
never going to get out. That's why I feel that, as black people,
we must look out for our brothers and sisters in our communi-
ties. Especially, when I think about black men, it starts from the
head, the father, and flows down.

Black folks as a whole have to realize that we have to work
for the total good of our race. The struggle is not an individual
struggle. I've heard people say, "I need to do *my* thing." Unfor-
tunately, that thinking causes us to go in separate directions
and be at odds. If we work together, everyone can have a slice of
the pie. That's the attitude me and Gerald have in terms of our
careers in the music business.

Bottomline, we have to start reaching back and spreading
the message of love. Love on any level covers a multitude of
sins. You are your brother's keeper, and if you don't have that in
your head, then you're not doing God's work. Just remember
that in order to love anybody, you've got to first love yourself.
And once you start loving yourself, then you automatically love
everybody!

I remember when you could leave your doors open late at night

And kids had to be in

When they turned on the street lights

Ah, them was the days

Remember your mama makin' you go get the switch

And your daddy coming home on Friday

Check is short, pitching a bitch

Now you got all these diseases, people smokin' crack

And mama's babies over there suffering in Iraq

—"Click A Glass," G. Levert, E. Nicholas/
Gerald Levert, *Do I Speak for the World*

Gerald

I think there is a desire in our community to do something about things like injustice and racism, and many of us see the need to create change, but the initiative is never taken. What I mean by that is that something tragic always has to happen, like somebody dying, before black people come together and do something. Before the problem happens is when people should be out there protesting or marching and speaking out. It's not that we as black people don't care about each other or want to help one another, but we'd rather choose to play it safe instead of taking that risk.

With Martin Luther King Jr., there had to be a lot of people in his ear telling him, "Man, you're taking a big risk. Think about your family, you have a beautiful wife and kids!" But he knew what he had to do in his heart, and he didn't let them affect what he felt needed to be done.

In order to be a leader of substance, you have to take a

stand and say, "I'm going to do this and I'm not going to listen to what everybody else is saying because they're afraid." That's why we have icons like Martin, Malcolm, even the Kennedys. They stood for something and they didn't care that what they were doing would endanger their lives.

As black people, even after the sixties, we've just been scared. I understand being scared, but somebody's got to step up. Look at how Latinos have come up and taken a stand for their rights, but we keep moving backward. Do you think racism is gone? Do you think white people who were racists back in the sixties just stopped being racists? Hell no! They don't have to call us niggers anymore, we do that to ourselves. No, they're in their houses and in corporate America quietly practicing racism. Nothing's changed.

When I was growing up, white people didn't want me going to their predominantly white schools with them. The only reason they accepted me was because my father was who he was. He could sing and dance, and to them that was just like a minstrel show. They accepted the "nigger" who could sing a song like "I Love Music." They'd say to me, "Yeah, we love that song!" Hey, I'm not in any way putting my father down, because he broke barriers. He's made major contributions to the uplifting of our race, but what I'm saying is, that's how they think.

got your back, and I'll go to the wall for you.

I got your back, and I will take the fall for you.

I got your back. I'm down for everything you do . . .

—"I Got Your Back," G. Levert, E. Nicholas /
Gerald & Eddie Levert, *Father & Son*

CLEVELAND, OHIO
JUNE 22, 2006
METRO SYNC STUDIOS

Of all the great songs on Eddie and Gerald's 1995
platinum CD, *Father & Son,* cut number two, "I Got
Your Back," was one of the most profound. Each song
on the record was christened with love and strong
family values. However, this track specifically speaks
to the hearts and souls of men everywhere. In four
words it sums up the kind of brotherly closeness that
Eddie has with his sons.

Gerald settles into the soundboard to get down to
the business of making hits. The studio is second

nature to him and one of his favorite places to escape the craziness of the world. It's the place where he transforms into the genius that has written and produced an arsenal of hit songs that have sold over 13 million albums worldwide.

"It's crazy, but *I got your back* is a saying that never goes out of style. Everybody can relate to it. When we were in the studio recording it, the vibe was very emotional," Gerald recalls with a robust, raspy chuckle, tweaking and adjusting sound levels with the control buttons.

"My dad was in one booth and I was across from him in another, and as I looked at him, the song began to take on a whole new meaning. The lyrics are powerful because they reflect and illustrate the special relationship I have with my dad, how I feel about him as my friend, and also on a man-to-man level.

"My dad and I have endured a lot in this business, a lot in our personal lives, too." Gerald releases a heavy sigh. "When I wrote 'I Got Your Back,' I did it because I wanted people to think about their dad, or their son, or an uncle, or your boy who is always down for you."

It doesn't matter if they're hanging out in the recording studio, at home, or performing onstage: when you witness Eddie and Gerald together, you *feel* their power deep down inside as well as that "realness" that Gerald speaks of so fondly. It's obvious that these two have made a pledge to one another that, no matter what, whether the chips are down or they're riding high, that they'll always have each other's backs.

"It's about being down for each other in the midst of adversity, doubt, whatever." Eddie gives Gerald a pound before head-

ing into the booth to lay his vocals down. "When I'm weak, my dad gives me strength," Gerald confesses as a soft smile creeps across his face.

Once in the booth, on the other side of the glass, Eddie belts out one of those spine-tingling, soul-filled notes, like the ones that earned him a place in the Rock and Roll Hall of Fame and international acclaim.

This recording session is filled with rare, almost sacred Levert moments. During the session, there are tense exchanges between father and son as they drive themselves to perfection; but there are tender moments, too. And as always, there is lots of laughter. Their laughter heals and erases the tension. None of this is either hokey or staged. It's simply who these men are, stripped down and bare.

Eddie

Fathers and sons have to keep it real with each other. It keeps their relationship alive. Me and Gerald are buddies, and what better person to be your buddy and tell you the truth than your son.

In our personal lives, we have no qualms telling the other person, "Hey man, you were wrong and should've handled that better." Even though I'm the father, I have to take it, even when I don't want to, and vice versa. When one of us is mad about something the other did, it's clear in our tone and how we address the other guy.

For example, if Gerald comes to me and says "Vert" and not "Dad," I know we have a serious problem. He might say, "Vert,

now you know that was some bullshit!" And he's right, until I prove him wrong! If there's a problem, one of us might get defensive or overly sensitive, and when that happens we have to remind the other that this is the pact we made, and we shake it off together.

Gerald

It's about telling the truth and being honest and straight up with each other. If I'm out of order or trippin', I may not like it or want to hear it, but I need to know. Sometimes men need for their egos to be checked! I think that you can only get that from another man. Men tend to accept advice and criticism more from a man than a woman, because we don't want to come off weak to a woman or like we're not in control.

It's important to be able to give your input and insight to other men on how to be a better man, a good man. With my male friends, I try to make them understand things like what they need to do to get respect from others. I might share my thoughts on what they need to do as far as raising their kids. But I don't try to tell them how to raise their kids, because I know I haven't been the perfect parent.

Not to say that everything I know is right, but there are a lot of things I've learned from having a father and other male figures in my life. A lot of my friends don't have a father in their lives. Unfortunately, even as much as I've tried to share those lessons with my friends, a man is going to do what he's going to do and that's the bottom line. Basically, you can have some influence on another brotha if he respects you, but you have to lead by example.

Some people aren't so fortunate

They aren't so blessed to have someone they can talk to

Somebody they can sit with and say I'll always be there for you,

 I love you, I got your back . . .

<div align="right">

—"I Got Your Back," G. Levert, E. Nicholas/

Gerald & Eddie Levert, *Father & Son*

</div>

Eddie

It's all right for men to lean on one another, and it's all right for men to cry, too. It seems like when a young man goes through puberty, he suddenly becomes his own person, and society starts telling him that men aren't supposed to be soft, or sensitive. So he's thinking, he's got to have a macho persona all the time, and that's not healthy. Men have to remember that we hurt, we cry, we're human like everyone else! We need the support of others who are of the same gender, so we can know that it's cool to be a friend.

It's all about us being more secure in our masculinity and a little more open with one another. For instance, men don't touch like women do. Women hug a lot. They spend more time with one another and tell each other their secrets. I feel like men have to begin to have a similar kind of communication with one another. Male bonding is not a "gay thing" or a "straight thing." It's an "us" thing, and about learning how to be more supportive of each other.

Gerald

So as the scripture says, "We are our brother's keeper." I'm supposed to look out for my brother and make sure that my

brother is doing the right thing. I'm supposed to protect him when I can, and be there for him when he needs me. I have to question a man who doesn't. It's about looking out for those who look out for you. You can't just run and leave a brotha who needs you, unless he's not holding up his end of the deal.

Some people might not have the same luck as you. I think a lot of things in life have to do with luck, and your boy might not be as fortunate as you. So, yes, that is a responsibility of yours as a man to take care of that person. If that brotha will listen, you try to do everything you can to keep him out of harm's way.

It's time men let go of our fear, anger, hurt, disappointment, and frustration toward one another. It's time to stop hatin' on each other and start communicatin' with each other!

Eddie

As men, we have to know that we support each other in all areas of life, in all situations. We're supposed to help build each other up. So to a certain extent, I am responsible for my "brother," but I can't help you if you're not trying to help yourself. If that's the case, then I have to be able to discern that and know that you don't want to be helped, and I need to move on to someone who's more deserving.

Do you wish that you could do yesterday over?

Does one's happiness depend on being rich or poor?

When you go through the airport do you feel misused?

Do you feel like you're being set up to lose?

Am I the only one?

Does someone feel my pain?

I get down on my knees everyday

Praying for change . . .

—"Speak for the World," G. Levert, T. Nicholas /
Gerald Levert, *Do I Speak for the World*

CLEVELAND, OHIO
JULY 26, 2006
METRO SYNC STUDIOS

"As a black man I've been troubled by what I've been witnessing happen to young black men in the last decade. The part that hurts even more is knowing that my generation, specifically the musical artists and

music that many of them have created, has played a big part in it!" Gerald swivels around in a hi-back leather chair, pointing to the soundboards in the recording studio.

As usual, Eddie and Gerald are hard at work in "the lab." That's what they call the studio. The recording studio is Gerald's second home. They've been spending even more time together here working on new songs for another father-and-son album in between Gerald's work on his next album, *In My Songs.* It's eleven-thirty at night and the mikes are just starting to heat up. Late night is the best time to record for pros like these guys.

There is a glint of fury in Gerald's eyes as he checks the sound levels. "Damn right I'm concerned about what's happening to the young brothas, because I have a teenage son. Maybe it had to hit home for me to get it all out when I recorded the album *Do I Speak for the World.*"

Eddie seconds the emotion. "More and more young men are being raised in a house where mama is both mother and father, and the father is nowhere around. Hip-hop videos are teaching our young black boys that hustlin', pimpin', and runnin' 'ho's and bitches' defines manhood."

"I love hip-hop. I'm a part of the generation that created hip-hop, but some of the music now is just ignorant. It ain't about good hip-hop. It's sad. Young black men need guidance and support," Gerald says, shaking his head.

Eddie

I've got two issues with our young black men: sex and education. First off, young black men have to get past this macho

sex thing that they have. They walk around acting like all women are bitches and they gotta be the pimp. They've got to get past looking at women as sex objects. Let's get back to the ideals and values and thinking that sex is for having babies. It's a private thing between *two people,* not three and four people at a time.

It seems like every music video is showing some rap star in the club or waking up in bed with two or three half-naked women. Are those really the messages we need to be promoting? No! We've got to start treating women like they deserve to be treated and put them on a pedestal.

Black men have got to come to the realization that if they're not being responsible, they are passing on sexually transmitted diseases like gonorrhea, syphilis, and AIDS. When you go bareback, without protection, mixing all those different bodily fluids, those are the risks you take. You're carrying these things from woman to woman. We can't keep doing this stuff!

Men have got to start caring more about ourselves, too, and what we're doing to ourselves. We've got to be selective. Sex is not just for fun. It is something that's very important and sacred in a relationship. But before you even need to be thinking about having babies and all that, it's about getting that knowledge.

It's crucial that our young black men go to school. You can't be any more ready for the future than by doing so. Make the effort and go to your classes, pick up that book, read it front to back, study it. That's what's going to open up the world to you. Education, a diploma, a degree; you can't be denied if you have those things. And if you keep putting in work, then everything will be all right.

Young world, the world is yours
You see, it's all about what you make of it . . .
　　　—"Crucify Me," D. Allamby /
　　　Gerald Levert, *Do I Speak for the World*

Gerald

Young black men are always going to be looked at as criminals and looked down on no matter what you do or what you acquire. If you ride around in a nice car, you're considered a drug dealer. Society has beat it into our brains that we are "minorities."

We have the power! We still believe we are the minority, and so we're out here always trying to prove that we're more. We think we've got to go and put on more jewelry or wear extra designer clothing. White people can walk around in raggedy jeans and a T-shirt.

It's like my comparison of The O'Jays to the Rolling Stones. The O'Jays got on studs and diamonds and the Stones have on torn jeans and ripped shirts, and they get a million dollars a night and the O'Jays get a hundred thousand. You feel me?

Most people I know want to show off and get a Bentley or a Phantom. They want to get the best new Mercedes or the Maybach. Instead of cars, they'd better think about real estate. Let's be smart like these rich white folks. Everybody doesn't have to know what you have. Enjoy it among the people that you care about and love. If you want to donate a hundred thousand to your favorite charity, do that instead of showing it off on your arm or finger, or around your neck.

You get tired of the blinged-out jewelry and the fancy cars after a while, and then you want some new stuff. How are you going to look at fifty with a platinum grille in your mouth? I don't like to use this word, but I gotta keep it real. That's nigga thinkin'!

I've been through it, that's why I can speak. I've gone and bought all the Rolexes you can buy. I bought all kinds of cars and drove them all. I got tired. Hell, you can only drive one car at a time. So okay, it's good to have two. If one breaks down, you can drive the other while it's getting fixed.

I can't say it enough. Let's be smart! As long as we keep doing this stupid shit, they're going to keep looking down on us and expecting us to spend money on worthless shit. For years I've been telling my dad that we need to get a plane. We could fly and do gigs when we need to and rent it out when we're not using it.

I went through a situation in 2006 with the Cleveland Police Department. Basically, a bunch of us, a few cousins and friends, were hanging out late at a club one night, having a good time, and on the drive home, the car being driven by a female family friend was pulled over by the police. I was in another car behind her and pulled over. I sat in my car for a moment, but decided to get out and ask if things were okay.

While I was talking to the police, unbeknownst to me, one of my boys got out of the other side of the car. The cops were suspicious and thought they were being ambushed. I tried to explain that we were cool, but they panicked unfairly. Tensions escalated and the police started beating me.

I feel like I let a lot of people down because of what happened that night. I can deal with the critics. You can't go

through life and expect everything to be wonderful all the time. I think the hardest part for me is that I don't want my family to judge me, and if you love me and you believe me, then you know my character.

I've never been one to take my success for granted, and think, "Oh hey, I can cut in line, because I'm Gerald Levert." I've never been one to feel like I should get a special seat or special privileges because I am who I am. I don't want anything special. When I'm out there performing, doing my job, I feel the people working for me should work as hard as I do. I expect them to and that's what I pay them for.

So, for the police to think I was trying to use a trump card and say "Hey, since I'm Gerald Levert, nothing should happen to me," no, that's not who I am, and I would never do that. If I'm wrong, I'm wrong. I deserve to be punished just like everyone else. If I'm speeding, I'll go pay my speeding tickets.

It's confusing because in one breath, as a celebrity, the powers that be give you a lot of things. I've got billboards and posters all over Cleveland encouraging kids to take a class in college. I read to kids. The city's given me honors, keys to the city, deputy's badges. I'm a member of the 100 Black Men of Cleveland. For the police to beat me was horrible.

I love my hometown, that's why I've stayed here all my life. But it hurt. Why give me all kinds of accolades if you're gonna just degrade me and kick my ass? That incident made me feel like all the love the city had shown me was superficial. To look up and see all white faces looking back at me was shocking.

I will say that after that situation, I see and know firsthand how it feels to be just a black man like everyone else. I've never

put myself in a position to be dealt with like I was that night. I was looking out for somebody else, making sure that person was all right, and it just wasn't cool for the police to treat me the way they did. They beat me up!

I know if there had been a black cop there that night, they would've recognized me and put a halt to the unnecessary treatment I received. I was violated, and it's something I'll never forget, and it's going to have an effect on the way I act and deal with people for the rest of my life.

When they took me to jail, and I saw all the young black men behind bars, it pained me deeply. These brothas don't have any goals. They have nothing to look forward to. They were happy just to talk to me. They were saying things like, "Man, we're in here with Levert!" I was the highlight of their life. I asked them what they planned on doing with their lives. I'd say, "Have you thought about going to school?" They would say back to me, "Man, ain't nothin' for me to do out here but hustle."

One young brotha had just done eighteen months and was about to do another two years. It's a harsh reality. What's happening to our black people? These brothas are on the phone with their families and attorneys saying, "Man, I only had two or three hollas!" (A holla is a bag of weed.) That's nothing to them. I wanted to say, "No, man, it's illegal! What are you thinking?" I just sat there and thought to myself, wow, this can't last like this!

What's going on is what he once said
Guess nobody heard him
—"No Man's Land," G. Levert, J. Little, N. Williams /
Gerald Levert, *Love & Consequences*

Eddie

When I was coming up in this business, you had more fathers and mothers together in the home, and kids had more direction. Even when there was just a mama who was running the household, she was strict. She was beating ass and taking names, and you didn't backtalk. There was just a stronger sense of values back then. This was before children started having children. Now you've got kids who don't have a good value system trying to teach their kids.

I do blame what's happening to the kids in our communities on the parents. It's still about parenting and regulating what your child is doing. I don't care if your children bitch and moan, you've got to discipline them. Tell that kid to get off the phone, go to bed, or wash the dishes!

Then you have a lot of young moms who work hard, and by the time they get home from work and cook dinner, they're ready to fall out. The kids simply go off and do what they want. The kids usually go straight to the television. On television, sex is everywhere, and the shows and videos glorify the lack of education and pimping, with black kids proclaiming, "I'm a pimp!" They have gold in their mouths, and their hair is undone. If you ask me, these kids are watching a lot of bullshit!

It's hard when I see what's happening out here in our communities, because my wife and I have children, and then I have grandkids. Gerald, Sean, and Kandi made it through unscathed, but see, it's getting harder and harder to raise kids nowadays. They see so much on television.

Another thing that makes me frustrated and sad is that kids today have what I call inbred racism. It's an inner racism,

racism against our own culture because they aren't seeing the things out here in life that can make them better. Even the white kids have bought into what we've been fed, and they've become illiterate. What's really messed up is that it seems like we can't do a damn thing about it because we don't have power over *the* power.

I really hate to do the typical thing and say it's because of the way white society still refuses to look at us as equal. Yes, it angers me! But the funny part is that white America tried to focus on the black community when it came to Ebonics and the whole hip-hop movement, and all of a sudden they found out that their kids were sneaking and watching BET, and coming out with their pants hanging down below their asses. How ironic. White America wanted to exploit hip-hop, but it back-fired and brought trouble into their own homes, and now their kids are rebelling, too.

Brother can you spare a dime
Money can drive some people out of their minds
—"For the Love of Money," K. Gamble / L. Huff / A. Jackson,
The O'Jays, 1974 #3 R&B, #9 Pop

Gerald

Young black artists today have what I call easy access to excess. Anything you want is there for you all the time—jewelry, clothes. We're at all the hot parties with the A-list people, even when most of us don't have A-list money. Every year something new comes out and everybody wants it. The guys want to find the new hot chick. The girls want the finest brotha who's paid.

Back when I started my career with LeVert, it wasn't about what you had. It was about the music and your talent. And then, when people started singing about and showing the things you can accumulate from performing, that became the standard for everyone, all the young up-and-comers. The standard became spinners on your car; no more gold, but platinum chains and ice; paying top dollar for sneakers.

It's ridiculous, especially if you don't have the money, but you're trying to keep up with the Joneses. I try to be hopeful that people will start focusing on the performance and the entertainment. But audiences are so enthralled with how much money Madonna spends on shoes for her child. Let's just be able to live a good life and be happy.

I can't tell people not to try to do more or that they should stay in the situation they're in. That's not how I think. Hey, I want more! But it all comes in time, and I think it all comes with honest hard work. There are so many other jobs outside of music and sports, like engineering, or becoming a writer.

Most young black kids aren't considering those occupations. They don't see that sports and rap records don't last forever. Look at a lot of the rappers. They overspend and end up filing bankruptcy. I want kids to understand that there's more to life than what you see on television and in the press.

I know there are a lot more distractions out here today than there were when I was a teenager. I want to encourage young black men to read more, and open their minds to new ideas and places. Think beyond just your 'hood or block.

I know most of the negativity young black men get caught up in today is because they don't have fathers at home. All I can say is keep your head up, young brotha, despite that. I give it up

to single moms. Just because she wears a skirt and her name is mother doesn't mean she's not playing father! Feel me? But single moms get tired, too. Understand, young brotha, you don't have to have a father in your household to find a father figure in your life. Maybe it's your pastor, maybe it's an uncle. Maybe it's a cat on your block with a lot of wisdom. You are not alone, and *we* got your back!

pray for love joy peace and happiness to be present in my home

And let your Holy Spirit dwell in my heart

and in my mind . . .

—"A Prayer," K. Gamble, L. Huff /
The O'Jays

CLEVELAND, OHIO
AUGUST 5, 2006
HOME OF GERALD LEVERT

"The older I get, it's becoming more and more important for me to have a stronger spiritual life," Gerald says, peering out of his large living room window that overlooks a lake. "Home is my place of solace and peace, and a man needs that."

Eddie stands next to him. Something has caught their attention. It is a lone duck that's found its way into the yard. "Even just how that duck is out there alone swimming around, sometimes you just feel alone. But then again, sometimes you have to find that solitude in order to seek a higher level of spirituality."

They retreat to the family room, where Eddie continues the conversation. "I've been feeling the same way. I look back at the early stuff me and The 'Jays sang. Even though we were an R&B group, the songs that introduced us to the world were sung in the gospel tradition. We could shout about the good news in the form of a good groove!

"'Put Your Hands Together' gave you the feeling that you were, as the old folks would say, catchin' the Holy Ghost. Many of our songs were rooted in the black church experience. When I sang the lyrics to that song, talking about praying for the poverty-stricken brothers and sisters, and lifting our voices in harmony, people at the concerts would actually get up, shout, and clap like they were in church.

"That's what I'm talkin' about! I have performed with gospel artists like Yolanda Adams and sang gospel songs with Patti LaBelle and Jeff Majors. I prefer to call them spiritual songs, because I respect the religious foundation my mom gave us. But God has given me a voice that when I sing those songs, it reaches deep down into people's hearts, and I want to keep spreading the message of His power in my music. I can be spiritual in my songs about my social concerns. Like Marvin Gaye did!"

The church, like so many successful African American musicians and singers, has played a vital role in both Eddie and Gerald's lives as singers and performers. Eddie was raised in the Baptist church and later became a Jehovah's Witness. Gerald and his siblings were raised as part of the Jehovah's Witness family.

"Studying, and reading the Bible, and believing His Word is what my life has to be about. Having a good spiritual life is about rejecting negativity. God has definitely sustained us in an

industry that, too many times, challenges one's faith." Gerald speaks with clarity and confidence about his spirituality. At the same time, Eddie's own spirituality seems to have been rejuvenated by the conversation. Whatever the plan, they both seem to have accepted that it's all in God's hands.

Eddie

In this life there are nonbelievers and believers. I'm definitely a believer, but at one point in my life I seemed to be in constant search of the truth in many different religious organizations. I discovered that you can't put your faith in man for life's answers. I've seen a lot of people grab that believer umbrella and use it just as something to walk under when it's convenient.

One of my favorite stories is the one where the guy is having all these problems, and the Lord says, "Just lean on me and it will always be all right." The man then says, "But Lord, there were two sets of footprints in the sand and now I only see one, why is that?" The Lord replies, "That's because I was carrying you."

Now, that may not be the story verbatim, but when I think about that little story, I know that God is my reason and my support, and through Him all things are possible. I believe you can't get anything in life without Him. So, at this point in my life I just try to stay on the straight and narrow and not take any of those side streets in life, but if I do, I try not to stay there too long.

When all else fails, and there's nowhere else to go; when they've backed you up against the wall and you're feeling hope-

less and lost; you can always turn to Jehovah God. He will give you the answer. It might not be the answer you want, but He will deliver you! All you've got to do is keep the faith and believe you can go as far as you dream in life.

When I get mad at someone, I don't try to get back at them or seek revenge. The Lord says, "Vengence is mine!" He can bring anybody to their knees until they give it up! When people talk to me about religion, I say, okay, let's forget about being a Mormon, or a Catholic, a Presbyterian, a Buddhist, a Christian, whatever. When you do the things that the Bible tells you to do, does life go better for you?

If it does, then what is wrong with doing what is right? Do unto others as you would have them do unto you. Love God first, then your mother and father, and then love yourself. You must trust and walk with God, and after that everything will fall into place.

> It'll be greater later
> Tomorrow's just a day away
> Things could change
> You just gotta keep the faith
> Pray on it . . .
> Don't give up . . .
> —"Greater Love," G. Levert, E. Nicholas /
> Gerald Levert, *Do I Speak for the World*

Gerald

Who on this earth has been able to make the moon come out or the sun rise? No one. My spirituality is just between me

and God. That's all that matters. I love Him unconditionally, because I know He loves me. He gave His son for our sins. He's always there for me, and I wouldn't be able to do what I do without Him. I don't have to see Him, but I feel His presence in all I do.

The one thing that He might not be so happy about is that I've gotten away from going out and preaching to people, and teaching them His way, and about the greatness of His power. I have to start doing that again. I did that early on in my life, growing up in a household where my mother was, and still is, a devout Jehovah's Witness. But when I got older, I struggled with music versus my religion.

I write songs and sing about life and love. If I do a sexual song, I don't want to be judged by the church. I feel like Gerald Levert the artist should be able to create freely. God gave me this talent! Just because I sing about making love doesn't mean I don't live by and believe in The Word.

I've never lost sight of the fact that you have to believe and have faith. Faith is the most important thing people need nowadays. People also must stop judging each other. Sometimes folks have their ways of thinking that what somebody else does or should be about is wrong. I am a Jehovah's Witness, but honestly, that was one of the biggest problems I found in being a Witness.

I was talking to a brotha who's a Witness the other day and he wanted to have a Bible study, and I said, "I'd love to have Bible study, but I cannot be judged by you. Now, if you can find a scripture in the Bible and tell me what I'm doing wrong in my career and in my life, then I can accept it." I had to stand firm on that, too.

The difference between me and my father, and how we handled being in the church, is that my father let humans drive him away from what he believed in. I would never do that. Look at Prince, who's a Jehovah's Witness. I'm sure they give him flak about the clothes he wears or maybe the songs he used to sing. But you can't let another man determine your fate or relationship with God.

I feel that I'm at a better place in my life. I do want to be as knowledgeable about His word as I used to be. I've been out on the road, and that's caused me to be away from being in the church, but I want to return to preaching and spreading the word of God one day.

PART THREE

Career

To be successful,
you've got to have the
fortification on the inside.
Your work has to
be legitimate, and
you've got to
work hard!

—Eddie Levert

CHAPTER EIGHT | I Love Music: PASSING THE BATON

love music, any kind o' music

I love music, just as long as it's groovy

—"I Love Music," K. Gamble / L. Huff,
The O'Jays, 1975 #1 R&B, #5 Pop

LAS VEGAS, NEVADA
AUGUST 19, 2006
MGM GRAND HOTEL & CASINO

The lobby of the MGM Grand is bustling and everything is blinging. Much like the tasteful "ice" Gerald wears around his neck, wrist, and on his ears. He's not big on flash, but with scores of platinum hits to his credit, he deserves to flaunt a bit of his star power, especially in a place like Vegas.

Gerald motions for "Big Joe" Bailey, his six-foot-six, 340-pound bodyguard, to check the time. Eddie is running a few minutes late to meet them. "Big Joe" makes a quick call and gets an estimated time of arrival on the senior Levert, who says he's just minutes

away, and confirms some last-minute recording studio details before taking a seat next to Gerald.

You can see the rapport Gerald and "Big Joe" have with each other is more brotherly than a formal boss-to-employee relationship. "Big Joe" and Gerald have been together for eighteen years. Joe is his confidant and friend, another example of the true meaning of the Leverts saying, "I got your back."

Eddie joins them and checks his own bling, a gold-and-diamond Rolex. They still have a few minutes before the car picks them up for tonight's studio session. Although Eddie lives in town and Gerald visits him when he's here, one of his favorite hotels is the MGM Grand. Gerald loves to gamble. He scans the room. "Craps is a lot like the music business. You put out your best, what you believe in, and the stakes are high. Either you could hit or lose it all." You get the feeling that Gerald is referring to the pressures from his record label about his next record. This is the first time the music hasn't been coming as fast as it normally does.

Gerald's words resonate with Eddie. Perhaps what he just said has combined with the flashing neon lights in the lobby to spark something. He turns and trains a strong and steady father-eye on Gerald. "I know you're pissed at the record company right now, but you can't let them get you down. We've got a mission with our music. I know what you're feeling. You just want to do what you love to do and not have anybody stand in your way.

"After The O'Jays recorded a song called 'Rich Get Richer,' in 1975, I had that same feeling. My whole thinking about what should happen with me and my family changed. I looked

at families like the Kennedys and said, 'Well, why can't the music business be *our* family business? Why can't we take this and make it what our family does? Whether it's performing, whether it's publishing, whether it's writing or producing, this is what our family can do.' I wanted to build a dynasty."

"I feel you, it's just about us continuing to take this dynasty to the next levels," Gerald adds. "This is a tough business, but you taught me how to be prepared so that I could take it on. A lot of people said we couldn't do it!"

"And they said it wouldn't last," Eddie says, "but I had a vision to have the whole family—cousins, nieces, nephews—involved. I wanted them to have an opportunity to go farther in life, and come out of school and into positions doing big things. Then you started LeVert, and now you are standing with me, leading this thing. I'm just proud we're all functioning in this music game in some fashion. Not many fathers can say that."

As they exit the hotel, "Big Joe" calls out to Gerald, "Yo, G, you wanna play a hundred-twenty-five on that hi-lo-yo, Man? That's a quick fifteen hundred. You know when you're hot, you're incredible. I've seen you hit back-to-back-to-back." Big Joe shoots him an encouraging smile. Gerald passes. Tonight it's about rollin' the dice on some new music.

Gerald has indeed followed in his father's footsteps. From his earliest days of watching his dad on tour with The O'Jays, to his first foray into the business with the group LeVert in 1985, his father's status in the music industry nurtured him and helped prepare him to become a successful writer, arranger, producer, and performer.

Hit songs, the love of good music, tough skin, and stamina are the reasons the Leverts still reign at the top of the R&B charts. In the highs and lows they've experienced in the music business, they've seen the good, the bad, and the ugly, and still managed to survive the "industry haters."

Eddie

I started out doing this music thing 'cause I wanted my family to be better. I came from the ghetto, and I wanted more for them. I wanted more for me. I wanted to be somebody. Do you know what it is when your dream comes true? When everything you've ever dreamed of starts happening? You're able to go in the store and buy things. You're able to go get that car that you like. You're able to go get that suit that you like. Now you've got the heart to go talk to that girl that you never had the heart to talk to. You've even got the heart to go get on that plane or go hang out in the club all night.

My dream came true, and music was my way of bettering my life and my family's life. It seems like one day I woke up and I could sing. I don't even know where I got it from. I know my mom sang. My dad sang a little, and I had people in my family who sang in the church. I started off just trying to sing what I heard on the radio, which really wasn't R&B.

Growing up in Canton, Ohio, they had this station where they played a little bit of everything: country-western, pop music, very little black music. So the only way we could really get a good dose of black music was late at night from a radio station out of Memphis. The show was out of a place called

Randy's Record Shop. Everybody would huddle around the radio just to hear some Luther Ingram, or some Gladys Knight and the Pips, or the Isley Brothers.

When I went to school, I used to walk through the neighborhood and I'd sing all the time. I've always had a strong voice, so most people say I'm too loud. This old lady would hear me coming down the alley singing and she'd open up her window and yell out, "Boy, one day you're going to Hollywood!" I was only seven or eight years old. I had no idea what she was talking about, and I'd say, "What am I gonna do in Hollywood?" "You're gonna be a star, that's what you're gonna be!"

So finally, when the chance came to make a record, my concept of what the music business was was way out in the stratosphere someplace. I thought that as soon as you made the record and you heard it on the radio, you got rich and could take care of everybody. It never happened like that.

I started off when I was sixteen. I didn't get a hit record 'til I was thirty-two years old. So I spent a lot of time disappointed and in obscurity. That's why I always told my sons that they had to be strong, keep pushing, keep fighting, and never compromise what you are as an artist for anybody or anything.

My style is rooted in gospel and the church. I cannot sing a song if I don't feel it, and if it doesn't have any gospel overtones, then I'll put some in there! I feel you have to live the song. I become emotionally attached to any song I sing. For that three or four minutes, that song is the only thing that matters in the whole world. I put my spirit and my emotions into it. It's like I get to a place where I just drift off and it's only me and the music.

Gerald

You can't please everyone, but with my dad, it's an even harder situation, because in the end, he's always gonna be *my* father. Sure, I try not to mix business with the personal, but he's my dad and it always ends up personal. So we've come up with a thing where we say, "Okay, this is Gerald Levert your business partner, not your son . . . This is fucked up!"

He's gonna have his opinion and I have mine, and I respect him, but I have to draw the line on when he's my dad and when we're in business together. He knows that I have delved deep into this business. I understand where The O'Jays lost, where they could've made more money or had more fame.

Eddie

I may not be as high up in the game as some of my white counterparts or even some of my black counterparts, but I am comfortable where I am. Remember—comfortable, not satisfied. Having seen my sons' successes from LeVert to Gerald's solo career are the achievements that count to me.

As far as my career is concerned, look, I've got an American Music Award, I got a Quincy Jones Achievement Award, numerous Soul Train Awards, I've never won a Grammy but I've been nominated, and I'm in the Rock and Roll Hall of Fame. Sure, I would like more of those accolades, but it's not going to kill me if I don't get them. What *will* kill me is if I'm not able to keep doing what I love to do.

Gerald

I wrote a song called "Can't Win," and at the time there were so many things I was trying to be and do for so many people, in my personal life, with my family, people that worked for me . . . just period. No matter what I did, it was never the right thing. In business, when you bring people up, you can't always win. I've always tried to look out for someone who I saw something in, but it seems like they soon forget what you did for them. They forget what you went through, what sacrifices you made to help them get to where they wanted to go.

Hypothetically, let's just say I introduce you to one of the greatest directors/movie producers ever, like Steven Spielberg, and he says you have everything it takes, and brings you in to read for one of his movies. Turns out you get a part, but you get mad at me because it's not the part you wanted! That's what I mean by "Can't Win." When people don't get everything they want, they point the finger at you, and once again you lose. Never mind what you did to help them get in the door. They think that because you have achieved *all* these things, or just based on the *perception* that you have everything you want in life, that you're winning. In reality, they don't have a clue. Most of the time, people don't know my real pain and struggles.

Eddie

Fathers and sons have to keep it real with each other. It keeps their relationship alive. Since we're best friends and business partners, we are our own worst critics on all fronts, career and on the home front.

When it comes to career, I tell Gerald what he should be doing, and he tells me the same. And if one of our performances is lousy, we have to be tough, so that we can figure out how to be better next time, and make this music thing work better. We're each other's eyes and ears. We have to let each other know so we can stay on top, even if that means being so truthful that it's brutal.

My relationship with music has not gone without stumbling blocks. The music business can beat up on you bad. It beat up on me so bad that I got to the place where I became very disenchanted with singing. I felt like I had put my all into it and then I got no reward, no kudos. Just like a relationship with a woman. You give that woman so much love, but when things don't go right and she doesn't give that love back, you get hostile and say, "I'm not going to keep giving you all of me, so that you can just keep hurting me like this!"

However, when I went out on the last *Father & Son* tour a few years ago with my sons, I felt renewed, and I began patching up my relationship with music and my singing.

Gerald

My dad fought for black artists to be recognized. Now today we have white people trying to tell us how we should do black music. I've tried to do the same thing in the trenches to prove that black artists deserve more because we're qualified and that we're something special. Everybody can't do what we do! We are R&B!

Eddie

I spent a long time in the trenches fighting for what I believed in. A lot of people don't realize or know that The O'Jays helped start the careers of the Al Haymons. Al Haymon is the biggest black concert promoter in the country. The O'Jays started other known promoters, Quentin Perry and the late Louis Grey, too. We were the first to let guys like them promote an R&B act from one end of the country to the other.

We're the reason black artists are getting paid the fees that they're getting now. Back in the seventies and even early eighties, black performers were getting paid only ten or fifteen thousand a night. We stood up and made them pay twenty thousand, then twenty-five. Then, after we got to a certain point, we said, "Okay, Mr. Promoter, you have to give us eighty percent of the concert sales and you're gonna take twenty."

This was unheard-of for black groups in the eighties. By the time Gerald came along, he was able to work with the same people we helped start, and they embraced him. Actually, Gerald and Al Haymon got to be as close as brothers.

Gerald and I conflict when I try to pacify situations. For example, recently he was upset by how the record company wasn't giving him the proper promotion and airplay he needs. I told him that he had to remember that these people have jobs, and they have people they have to answer to. And he just cut me off and said, "See, Dad, this is what pisses me off about you, you and that psychological bullshit!"

I wasn't trying to psych him out, I was just trying to get him to see the whole picture and give him the example that maybe one person at the record company might be feeling Eddie or

Gerald Levert, but maybe their boss, whoever they report to, isn't. In that case, that person's hands are tied. But Gerald wasn't havin' it. For about three weeks after that, every time I tried to open my mouth about something, he'd cut me off and say, "That's that psychological bullshit!"

That's what I love about my son. Gerald doesn't hold back when he comes at me. I respect that. He also is able to understand my plight as an artist. Then he created his own group and ultimately went solo. He's proved himself, just like me. He even stays committed to supporting and fighting for the rights of musicians and singers on issues like unpaid royalties through the R&B Foundation.

The fact that I work hard to be the best, I know puts extra pressure on Gerald. Some days we get into real scraps about it, because he gets mad and blames me for that pressure. But he puts pressure on himself, because he's taking this whole music game to another level. A level I was unable to reach in the prime of my musical career.

Perhaps time isn't allowing me to reach it now. I watch him, and he goes through so many changes as an artist and as a businessman. It's a heck of a burden, and I never wanted to put my burden on him, but it was inevitable. When you're in the position he's in, you don't just worry about yourself. You worry about everybody else in the family's livelihood, too.

Ultimately, I just want Gerald to realize he's not alone, and that I've put a lot of pressure on myself, too. I push to make this old body do things it's not supposed to do, not only when I perform, but in life. Through all my ups and downs, I make sure that every day, I work hard to clean up my act as a human

being by being more honest and open, eating healthier, and trying to look and feel as good as I possibly can. But I haven't lost my competitive spirit for music, so I get excited about the next phase of where the Eddie Levert and Sons legacy will take us!

PART FOUR

Love and Relationships

It may sound corny, but honesty and trust are the foundation of any relationship. When you tell the truth to the man or woman you love, it tests the strength of the relationship. Even if it's confessing something negative in your past.

—Gerald Levert

I was made to love ya

My hands to touch ya

My arms to hold ya

My legs to stand

My time to spend

With you forever

I was made, made to love ya

—"Made to Love Ya," G. Levert, E. Nicholas /
Gerald Levert, *Gerald's World*

RIHGA ROYAL HOTEL
NEW YORK CITY
SEPTEMBER 6, 2006

Eddie and Gerald's music speaks the language of the heart, making women scream and moan, and grown men cry. "Our songs have explored love, romance, relationships, and women in every way imaginable. We can take you from the dance floor to the bedroom!" Gerald flashes a grin. Father and son are chillin' in the Rihga Royal Hotel lounge in Manhattan before their

evening recording session starts. It's the perfect setting and ambience for a conversation about some of their most provocative works.

Gerald and Eddie do a playful rundown of their biggest love songs. "Me and The 'Jays gave you 'Stairway to Heaven,' 'You Got Your Hooks in Me,' 'Wildflower,' 'Sunshine,' 'Let Me Make Love to You,' just great ballad after great ballad," Eddie says.

"Those were some of my favorite 'Jays records!" Gerald interjects. "That's what inspired me to keep the baby-makin' tradition goin'!" The two share a laugh. "'U Got That Love,' 'Thinkin' Bout It,' 'I'd Give Anything,' and our big duet, 'Baby Hold on to Me.' Even with LeVert, '(Pop, Pop, Pop, Pop) Goes My Mind,' 'My Forever Love,' 'ABC-123,' and 'Baby I'm Ready' were some of the best songs I've written."

"The best part of my job is making people want to fall in love and make love!" Eddie reflects.

"For us it's always been about creating music that's telling the truth about what men and women want. Sometimes women want it just as bad as men!" Gerald winks then lets out a big laugh. It is obvious why he's affectionately called "the Teddy Bear" by legions of female fans.

"All the big love songs me and The 'Jays sang meant a lot to me. 'Stairway to Heaven' was a reflection of what I was going through at that time. We didn't write that song, but it was like the writers knew what was happening in our lives. I was emotional. I've never had a woman in my life that I didn't care about, so that's why I could relate to it."

The 'Jays would go into Philly a month or two in advance

to record at Philly International. All the writers would present songs and we'd pick out the ones we wanted to record, and then we'd go rehearse with Gamble and Huff, Bunny Sigler, or McFadden and Whitehead. As we'd rehearse, they'd go cut the music. A lot of those albums we cut in one night. We'd do the background and lead vocals, and sometimes cut twelve songs in one night if we went in at ten and came out at six in the morning.

We would know those songs by heart because we'd been in Philly for weeks already. It was about living the song, knowing the music backward and forward. That's why the songs came out so great. I remember picking 'Let Me Make Love to You.' Bunny Sigler taught me that song, and I sang it every day with him until it became a part of me."

The waitress sets down two glasses of top-shelf cognac for Eddie and Gerald. "Our music definitely has helped a lot of people in their relationships. We're blessed to be able to come up with the right words to say," Gerald says, picking up his glass and swirling the thick, dark liquid around. He sips slowly. "It works for me, too, sometimes. I've had some ups and downs in the love department"—he pauses—"but not many!" Eddie and Gerald let out a boisterous round of laughter, raise their glasses, and toast.

Gerald

It took me a long time to get over when my father left my mom for another woman. I was eighteen, and that was a crucial time for me as a young man just stepping into manhood. His

leaving my mom and hurting her was probably the one thing that really drove me to work harder and outdo what my father probably thought I could do.

The woman was the mother of a good friend of mine, who I had gone to school with. I was devastated because I felt me and my father should've been able to combat the situation together, talk about it, and work things out. I thought he and I were closer than that and had more of a friendship, but I was wrong. My friends knew what was going on, but I didn't. I was ashamed.

I knew my father wasn't an angel, I knew that he was partying hard back then; he was a star! Prior to this happening, I wanted us to have that secret, but when he let the secret out, I was pissed at him. My mother was hurt and that angered me.

I always enjoyed my father being on tour, because I knew he was coming home. That's what made us a family, and when we were no longer going to be a family and those days were over, that hurt me. That hurt me a lot. That really made me want to stand on my own. I no longer wanted to hear what my dad had to say. That was my way of rebelling.

I knew that men make mistakes, but *not* my dad, *not* my idol! All I could think was, he can't make mistakes and not talk to me about it. I'm your boy! When it all came out that my dad was having an affair, I didn't tell my mother. I didn't because I was still thinking, "Okay, we can be together as a family forever." I didn't want anything to break up our home. Maybe that was a selfish thing to do, but that's how I felt.

After I got over the whole thing and I became a celebrity myself, I realized how hard it is to keep yourself away from those temptations. That's when I stopped idolizing people. I

never stopped loving my dad, I never stopped having deep feelings for him, but I realized he was a man and men are imperfect.

> Your body's here with me
>
> But your mind is on the other side of town . . .
>
> —"Your Body's Here with Me (But Your Mind's on the
>
> Other Side of Town)," K. Gamble, L. Huff / The O'Jays

Eddie

I come from a generation where we bought into a lot of infidelity, not being truthful in a relationship, free sex, having babies outside of wedlock, and all of that. I went through a period where I was womanizing, but I've only had three women in my life who I loved and chose to be with—my first wife, Martha, a woman named Patricia, and my new wife, Raquel, but I'd had many relationships in between. I'm a passionate and emotional man. I couldn't be with you and not care about you. Unfortunately, that passion got me in trouble.

With the song "You Got Your Hooks in Me . . ." I *loved* that hard at one point in my life, same with "Your Body's Here with Me (But Your Mind's on the Other Side of Town)" . . . I've lived that! When I recorded that song specifically, it reflected what I was doing at that time. I was just out there doing what I call "free-willin' and rockin' it." Basically, I was stepping out on my marriage. I would be home, but somewhere else at the same time.

I loved Gerald, Sean, and Kandi's mom. I love her now. Martha is a great woman. The reason we got divorced is because

she didn't deserve for me to treat her the way that I did. I had to let her go, because if I wanted to find grace in God's eyes, I had to do the right thing. She was too good a person for me to keep doing her wrong.

My second marriage to Raquel has been wonderful for me. Of all my relationships, this is the only one that I've played straight ball and on the level. It's funny, women are a lot different than men. They'll be dedicated, committed, and love us until we mess them over really bad. Then it's over. They will cut you off.

When I lie, I start sweating. I'm a terrible liar. My stepmother used to always tell me one lie leads to another, but if you just tell the truth you'll make your life so much easier. Men are fickle! It took me a long time to apply that lesson to my life. Now I have one woman who I love, and I'm totally committed to her.

Gerald

My dad's marriage was a shock, even though I kind of knew it was going to happen. Up until right before the wedding, he really never came straight with me about the marriage. How he acted caused me to react negatively. I think it all started when he came to me about going out on the last *Father & Son* tour. He kept stressing the importance of the tour.

I think he was looking at it as a way to try to spend time with me and Sean. I'm sure he thought and hoped being out on the road would make telling us easier. But he didn't know how to do it, and he never did until it was almost time for him *to* get married.

When it happened, it was like wow! I knew he had been looking for rings, but I was waiting on him as my friend, as my man, as my best friend to tell me straight out what he was doing, but he never did. It all came out more like, "Hey, I'm scared and I don't know what to say." I kept saying, well Dad, let's talk about things, but he wouldn't.

I knew in my heart that he really wanted to tell me something about getting married. I thought being on tour would give him the time to come clean with me, but also get his thoughts clear about the kind of commitment he was about to make. When he finally told me he was getting married, he was very nonchalant and downplayed the entire wedding. I felt that wasn't the way a father invites his kids to his wedding.

So we were doing a show for the Urban League, and the night of the concert was a week before the wedding. The atmosphere was very tense, and my father and I had an argument about the show's wardrobe. I knew it all stemmed from his anxiety about the wedding. My brother Sean was unsure about going to my dad's wedding because my father didn't go to his, and Sean's always held that close to his heart. My sister Kandi had already decided to go to the wedding with her family.

I called my mom, and Sean and I talked about our feelings, and we decided to pass on the wedding and go back to Cleveland and take our mother out instead. We wanted to treat her like a queen that night to make up for the void she must have felt.

In retrospect, the thing that was really deep at that time was that I was going through all the legal problems with the Cleveland Police Department, my name was being splashed all over the news, and everyone else around me had been expressing their concerns and, for the first time, my father didn't say very

much. I think it was because he had his own issues going on with the wedding. I expected more from him, and I didn't get a lot of his support like I thought I should have, and that hurt.

It was a stressful time for me. I had big decisions to make, like whether or not I should go after major political figures to help me get through my legal woes. Then I went out of the country and was indicted. I was being hit with all kinds of charges, and I didn't have my father by my side. I had to use my own judgment, and even though the judicial system came at me from every angle, I survived.

Afterward, I really couldn't talk to my father about what I had gone through because I think he still had some animosity toward me and Sean about not showing up at his wedding. I'm glad my sister went. Sean and I definitely had a harder time with the wedding situation. Maybe it's that mother-son thing. You know, boys tend to be even more protective of their mothers.

All I could think about was the fact that my mom and dad were married for twenty years. I don't think she's ever dated anyone since, and if she has, it's secretly. If she does find somebody, I know my brother and I are going to be hard on him. That night my dad married Raquel, she needed her sons to help her keep the wedding off her mind. I wanted her to go to bed with a happy feeling.

I eventually spoke with my dad and Raquel and told them both how I felt. If my dad's happy, that's what's important. I just don't like the way he chose to handle telling me, my brother, and my sister. We could've been more aware. Telling us at the last minute just wasn't right. There were outsiders who knew more than we did, and that didn't make us feel good.

Think about this, pillow talk is the most important form of talking that two people have. Sharing your bed is a special thing. So after a long, hard day, if you're crying or you're hurt, the person lying next to you is the one who gets an earful. That's your most vulnerable time; you're able to be open and share your secrets.

I'm not the one who's lying next to my father. The person in bed with you is the person who hears your last words before you close your eyes and go to sleep. Before my father got married, he would call me before going to bed. So now he has someone else to share those feelings with.

When did you stop loving me?
What did I do so wrong that you had to leave?
When did you stop wanting me?
No letters, no call
Girl, you know I'm needy
Baby, this thing has took its toll
On my mind, my body, my soul
Can't get you outta my system
Out of my head
Out of my future
Out of my bed
I hear your name
I see your face
I lose all composure
I need to see you one more time
I need closure
　—"Closure," G. Levert / Gerald Levert, The G Spot

Eddie

It took me all the way until my fifties, when I met Raquel, to find something that I really wanted to do, and it shook me up at first. I couldn't believe I had found somebody that made me say, "Hey, I'm not messing around." I decided to give myself a chance and play it straight for once in my life.

Gerald and I have gone through our hard times, with him not understanding that I'm in my sixties and Raquel's in her thirties. Sean and Kandi had issues with it, too. Gerald was definitely more vocal with his initial disapproval. He even said to me, "What are you doing?" I had to tell him that I'm the same man he's known all his life. I'm no idiot.

If I give my wife the moon, it's because I love her enough to give her the moon. When I decided to get married again, it was because I wanted to. No one twisted my arm. But Gerald cared, that's why he confronted me. For the longest time, Gerald and Sean didn't want to acknowledge Ryan when she was born.

I think their feelings were all tied in with the fact that I was marrying a woman much younger than me. It wasn't a personal attack on their baby sister. However, Kandi acknowledged Ryan right away, and I prayed Gerald and Sean would eventually accept things. I was so happy when a couple of years ago they started showing how much they care for her.

I can understand. My sons are protective of me. They wanted me to be happy, and at first they were skeptical about Raquel. But then they stepped back and observed and saw how real our love is. Now they realize and understand that we're all grown and they can't run my life, just like I can't run theirs.

Yes, I want Gerald and my other kids to like my wife. I'm

not asking them to call her "Mom," just like her children don't have to call me "Daddy." However, they have to respect me and they have to respect her, because she is Mrs. Levert now. And maybe I'm an old fool to a certain extent, but I wasn't when it came to falling in love with a good woman.

It all boils down to one thing: When you find something that's real, you need to do the right thing! It's a shame I had to get to be as old as I am now before I had the ability to give someone the opportunity to be all they could be in my life without being a jerk and a cheat or a liar.

All of a sudden Gerald had become overprotective of me, the way I was about him and my other kids when they were younger. But then I had to get over it, because they all went and did what they wanted to do anyway. As a parent I had to let go and get over the nurturing thing.

Kids are selfish and don't believe in sharing. All my kids have an attitude about my marriage. Gerald's become a man, and as a man he picks and chooses his own role in life. I'm not an important factor in that anymore. I'm still his father, I'll always be, but I have a new life now.

At this point, I think Gerald and I are on the same page. Even though I know he was upset about my marriage, in a strange way, I think this all has helped him become more independent, as he should.

> I want someone who makes me happy
>
> I want someone who loves my bad days
>
> I want someone who's spiritual
>
> I want someone to keep my secrets
>
> I need more than just physical

If you want rain or shine
If you got love
You can have mine . . .
—"Got Love," G. Levert, E. Nicholas /
Gerald Levert, *Gerald's World*

Gerald

My dreams of success have come true. I've headlined my own tour, written my own songs, and worked with a lot of great people, but I'm not totally fulfilled. I've come to the realization that it's no fun being successful and alone.

It's wonderful being around my kids and my dad, but some things you can't talk to your son, or your father, or even your male friends about; they just don't understand. There's nothing like having a relationship with a woman who accepts and understands you for you.

When you mature, you stop caring about the stupid things you cared about when you were young. For example, remembering how I used to say things like "She isn't fly enough" seems silly now. All that type of thinking is surface, and as you age, you get past that. At this point in my life, I don't want to do all that arguing and fighting with a woman, either. It's about finding a mutual connection with someone I can ultimately talk to about everything.

Just let me make love to you, baby
I won't hurt, I won't hurt
—"Let Me Make Love to You," B. Sigler / A. Felder,
The O'Jays, 1975 #10 R&B

Eddie

My sons are my best friends. We talk about sex, and women, and our relationships, and everything. There was a time where if I would've said something negative or out of frustration about how their mother handled something—like, "Look here, your mother isn't really feelin' what I'm talking about!"—they would've gotten mad or defensive and said, "Man, you can't talk about my mama like that!"

But now that they've grown up and dealt with women, they understand and they see that women are very complicated and can be difficult. But I'm not letting men off the hook, either. I've looked at my own actions, and I'm much more supportive and attentive now that I'm older. I've learned patience and I'm glad. Now I'm not so quick to react and judge.

I do think black women have to be softer, though. They need to know that when they have a good man, they should appreciate him. Most black women get a good man, and then say he's soft. Why? Because he wants to cater to you? Or be more understanding? No; that means he loves you.

I married a woman who has nurtured me through some very rough times. Recently I broke my foot, and she washed me, cleaned up after me, and took care of me. People don't have to do that, some people draw a line, but she didn't. She's not the first woman to do that, but it made me love her and want to be with her even more. I have a lot of respect for people who can humble themselves for another person. The love we have for each other is unconditional.

I'm not going to fool myself and say I'm all that at this age, and I don't want to try to fool a woman into thinking I

am all that or that I've got enough money to just give you some and not miss it. But I was with Raquel for ten years before I married her.

What else do you have at sixty-five to look forward to other than trying to have a sense of happiness and peace, someone to love, someone to come home to, someone to share your home with? Money can only buy *things,* and yeah, it's important that you're able to buy things and provide for the ones you love, but love means more than all that.

> Heaven knows how I've longed for this
> Ever since we kissed
> Anticipation is killing me
> 'Cause I want to be your favorite fantasy
> Talk to me, tell me where your spot is
> Where you're sensitive
> 'Cause I want to concentrate
> On all those things . . .
> What makes it good to you I wanna know
> And I won't be happy til you scream no more
> Say it's yours
> No premature lovin'
> What makes it good to you
> —"What Makes It Good to You (No Premature Lovin')"/
> G. Levert, T. Nicholas, *Gerald's World*

Gerald

If a man has an issue or an unhealthy relationship with his mother, he's likely to treat women negatively. There are a lot of

men out here who aren't nice to women, and I think that has to stop. Even though women can be frustrating and relationships aren't easy, I can't conceive of treating a good woman badly. I love women. My favorite part of a woman's body is her lips. They're great for kissing, licking, biting, and sucking. Talking before, during, and after making love is great, too.

Sexy to me is when a woman's hair and nails look good and she keeps herself in shape. It shows she respects herself. But also when she can look out for her man and make sure he doesn't want for anything . . . That's a bad ass . . . shut your mouth! It's not even about lingerie. Some women can wear thermals and be sexy as hell. Bubble baths are sexy, too. But there's nothing sexier than a shower for two.

The most romantic thing a woman can ask me is, "Are you okay?" It shows she really cares. When I'm being romantic, I dig the lights being on. Sometimes you need to see what you're working with, but lights off with scented candles set it all off, too! Music is cool, as long as it's not my father singing. That would be like him trying to tell me what to do.

Eddie

Sometimes during the day you should touch your woman, let her know that she's appreciated, and that you needed to touch her face, hold her hands. These are the things we have to do as a man for a woman. I think black men on a whole need a woman. They need to make that decision to say, "Hey, I got this woman and I'm gonna give it my all. I'm gonna play it straight instead of holding something in reserve."

Black women have to do the same and stop looking for that

man in the magazine ad. Just look for someone who is trustworthy. Someone who's got honor, someone who has respect. Then, men, walk straight. Our problem is, we get caught up in "I wanna hit that."

We gotta get over the "I wanna hit that" syndrome. It's not about just getting some casual sex. It's about finding a friend you can trust and building on love. "Hittin' it" leads to all these other things, like babies without daddies. I know, I've been there. Fellas, treat the woman with respect.

That's why I have a hard time with the rappers and young hip-hop artists now. All they wanna talk about is "I'm gonna get my buzz on," or get high, "I'm gonna get my drugs. Then I'm gonna get me a woman. Then I gotta go do the show. Then I go get my money. And then I'm gonna go get some pussy!" Guys, that's not a way to live your life. That leads to nothing.

Men gotta realize that when you just "hit it," that person might have felt like it really meant something. And now that you've just "hit it" and run off, there are hurt feelings you're leaving behind. It might have an effect that's so big that after that, the person's damaged goods and their behavior is unhealthy in the next relationship. It could have a trickle-down effect. Or you hurt this one, you hurt another one, and that hurt just keeps going on.

'll care for you, be there for you

I'll share with you

I'll understand, I'll be your friend

That's my definition of a man

—"Definition of a Man," G. Levert, E. Nicholas /
Gerald Levert, *Love & Consequences*

CLEVELAND, OHIO
OCTOBER 17, 2006
I GOT YOUR BACK BOOK PHOTO SHOOT
(GERALD'S LAST SHOOT)

Today is a monumental occasion. Eddie and Gerald
are shooting for the cover of their first book.
Although the duo has had hundreds of photo shoots
in their careers, this is the most significant because it
is for the cover of their first book. Famed photogra-
pher Dwight Carter is focused on capturing the
essence and soul of these two men on film.

Eddie and Gerald have a strong and diverse fan
base. Their music has touched the hearts and souls
of audiences around the world. Now they have an

opportunity to touch their old fans as well as gain new ones in the literary world with *I Got Your Back.*

Dwight begins clicking away and flashes ignite the room. "At one time, before Gerald came along wanting to be in the music business, it was just me, Eddie Levert of The O'Jays. Suddenly I wasn't in this music thing alone anymore." Eddie and Gerald strike a pose. Gerald is seated in a leather lounge chair and Eddie leans over his shoulder.

"Often people would say to Gerald, 'You want to follow in your dad's footsteps? How are you going to do it? He's such a great man. He's done so much! All this, and all that.' Then, after Gerald got in the business and he became so good, it took another twist. The same people came to me and said, 'What are you going to do now that your son is taking over?'"

More flashes and clicks . . .

"In the song 'Wind Beneath My Wings,' the first line is: 'It must've been cold there in my shadow . . .' To me it was never cold. Gerald is my son, and I always wanted him to be a success and be as big as he could ever dream to be. This is a tough business and you've got to believe that you're good. I've always had a lot of confidence in myself, and that's the one thing that I tried to instill in him. Remember, I never would have put him in the game if I didn't think he was qualified. This industry is competitive, but why would I want to compete with my son? All I ever wanted him to do was be proud that I was his dad, doing my job, and taking care of business."

Dwight pauses and motions for his assistant, Norman, to adjust the lighting and get ready for the piano setup. It is a big production to move from one room at the studio across the hall

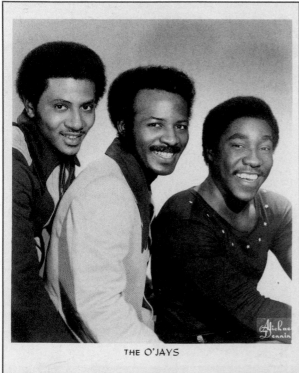

THE O'JAYS

Left: The O'Jays.

Below: LeVert! (Gerald Levert, Sean Levert, and Marc Gordon).

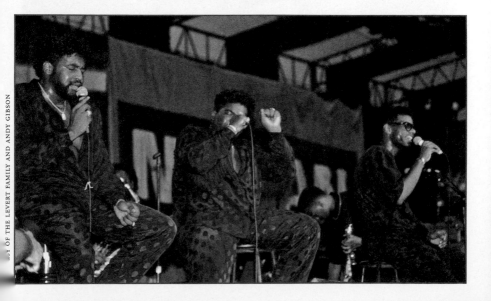

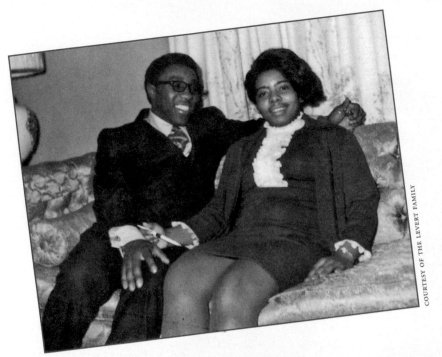

Eddie and first wife Martha Levert (Gerald's mom).

Eddie with his children Kandi and Sean.

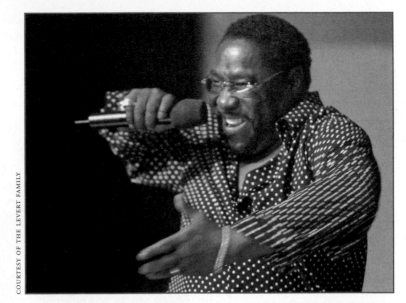

Eddie doing what he does best.

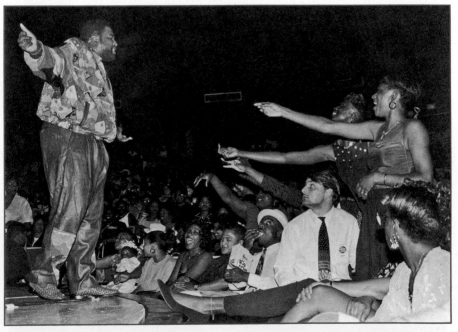

The "Teddy Bear" giving his all on stage.

Eddie and Gerald
with Don Cornelius
on the set of
Soul Train.

Gerald with the group
Men at Large in the studio.

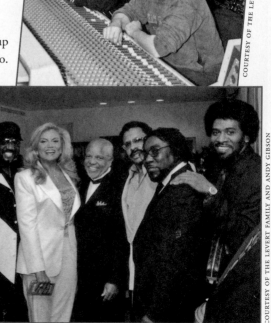

Eddie (second from right) with Suzanne dePasse, Berry Gordy, the O'Jays,
and the Temptations.

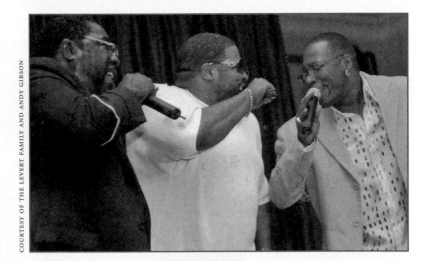

Above: Gerald performing with Eddie and fellow O'Jay Eric Nolan Grant.

Left: Father and son at the Urban League Awards, 2002.

Below: Oprah Winfrey and Eddie.

Eddie, Sean, and Gerald.

Eddie and his wife, Raquel Levert, with musical director
Dennis "Doc" Williams and his wife, Donna.

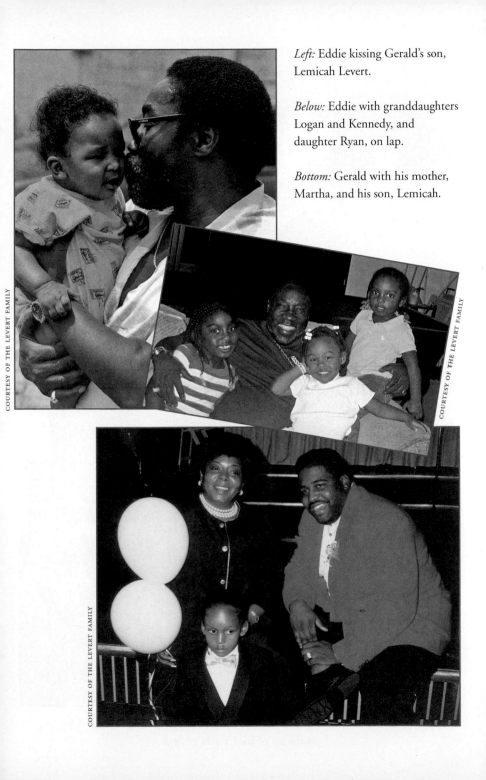

Left: Eddie kissing Gerald's son, Lemicah Levert.

Below: Eddie with granddaughters Logan and Kennedy, and daughter Ryan, on lap.

Bottom: Gerald with his mother, Martha, and his son, Lemicah.

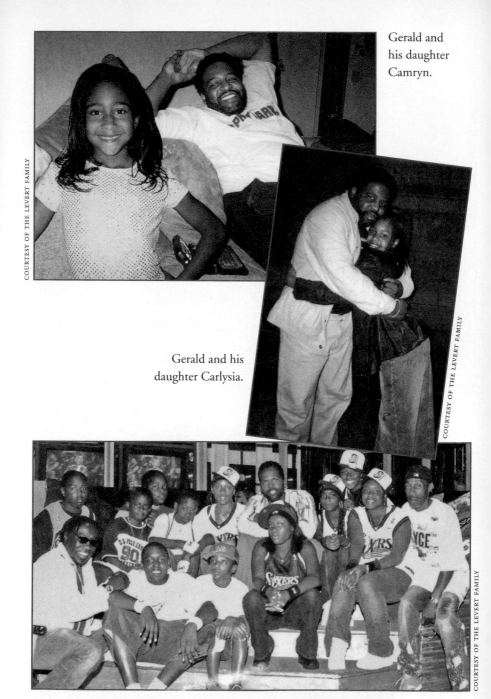

Gerald and
his daughter
Camryn.

Gerald and his
daughter Carlysia.

Eddie (far left) with grandchildren, brother Reggie (far right), and A.J.
on the set of BET's *106 & Park*.

to another. There are lots of laughs along the way, but the mood is serious, there's work to do.

Various members of the Trevel Productions staff as well as hired hands for today's shoot move about precisely and quickly: Murph, the wardrobe valet; Chandi, the key administrative assistant and project coordinator; Juliet, another assistant; "Big Joe," Gerald's confidant and security; Alvin, the barber; Sharon, the makeup artist; Leonard "LB" Brooks, Gerald's manager; Reggie, Eddie's brother and right-hand man; Kandi is catering the shoot.

Andy Gibson is excitedly documenting the day with his video camera. Some of the folks present are blood related; others aren't, but based on the many years of history with Eddie and Gerald, they may as well be. The Leverts keep a loyal, tight-knit crew around at all times.

Dwight begins clicking away again. Gerald stands behind his dad, who is seated at the piano. Dwight asks Gerald to be candid about what he could say to sum up his relationship with his dad. The trick is that he wants Gerald to do it as if Eddie weren't here. Gerald pauses, then begins to speak: "I want my dad to know that I've always been proud of what he's done and his accomplishments. I've always looked up to him as an idol, as somebody I wanted to be like. I never really cared about being in his footsteps, because those are big shoes to fill.

"When I was younger, I knew what came along with him being a star, all the *temptations* . . ." Gerald and Eddie share a chuckle. "I played naïve, because deep in my heart, the music business was what I wanted to be in, too. I guess I just thought I could make better choices than my dad did; I found that it's not so easy."

Eddie gives him a look. "Damn, Man, that was kinda deep." There's another pause. Then he and Gerald burst into that great laughter. This is their style. The beauty of their "brutally honest" relationship is that they keep it real, and they keep the laughs coming. Eddie clears his throat. "When someone asks me how I feel about being back on top, I laugh. I don't think I ever really got to the top of where I wanted to be. When I perform with my sons, Gerald and Sean, they give me that shot in the arm that puts me back on top.

"I don't necessarily have to be on the top of the music charts. My sons give me the drive to wanna get up there and sing, and throw the mike around, and run across that stage, and really feel it. Being with them is like getting new energy, taking me to a new level. I might go on 'til I'm a hundred!"

Dwight directs Eddie and Gerald to switch places and rechecks the lighting. He pauses and asks both men what their favorite songs are of their own that they've recorded, as well as one by the other person. The guys snicker at the questions. Eddie goes first. "I'd have to say 'Back Stabbers' is my favorite 'Jays song. I just love the production on it. It was our first big international record.

"What was so great about it was that I saw it progressively go up the charts and become a hit record. We started singing it with just the piano player and the writers. Then it went to the studio and they did the rhythm track and it sounded great, then the background vocals made it really sound like it was goinna be something, and the lead vocals got on there and you just knew there was something going on with this, and when they did the horns and strings, I was like yeah, it's a hit song! My favorite Gerald song is the one he does in the falsetto . . ."

"Closure!" Gerald interjects.

"Yeah, I think that was him growing into a young man as a performer. It was his transition into being a full-grown artist to me!"

"My dad likes to give a sermon when he talks, but I'll just keep it simple. My favorite 'Jays record is 'Let Me Make Love to You.' Why? Because it's the best question to ask! And my favorite Gerald record is 'Made to Love Ya.' Why? Because I was!" The room swells with that contagious Levert laughter. "All jokes aside, I'm excited about this book because it's been a lifetime in the making. I hope that with it, every father and son out there can get what we have . . . friendship!" On that final high note, Eddie and Gerald break pose and give each other one of their famous man hugs.

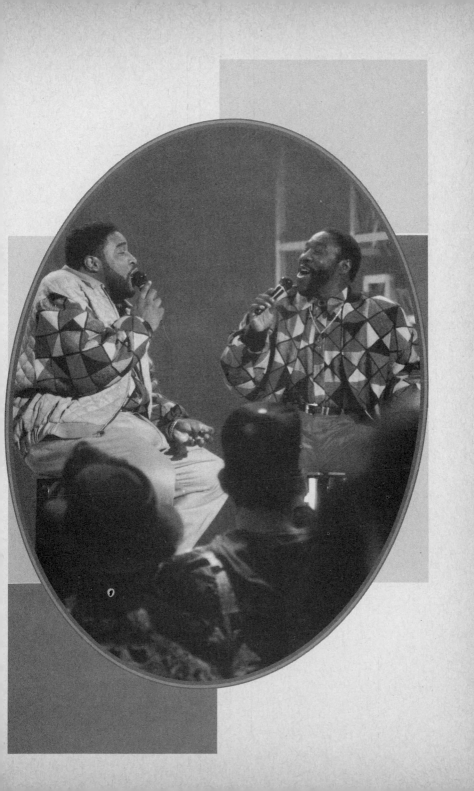

Now I lay me down to sleep

Hope that you are proud of me

If I should die before I wake

Remember all these words I'm saying . . .

—"Humble Me," G. Levert, E. Nicholas
Gerald Levert, *Love & Consequences*

Gerald passed away less than a month following the *I Got Your Back* photo shoot, leaving millions saddened and stunned. However, in the wake of his death, friends, family, and colleagues began to remember and pay tribute to Gerald's remarkable life. Here are some of those personal reflections that celebrate Gerald and the spirit of the amazing friendship he shared with his father.

Sean Levert

Younger brother and LeVert member

One of LeVert's funniest stories from the early days, which probably wasn't so funny at the time, comes to mind. We used to fight all the time when we were together as LeVert. Yeah, physically fight! Gerald could turn into King Kong back then.

I remember when we were first starting out, we had a club date in Youngstown, Ohio. I think there may have been six people in the audience.

So we're doing our show, and those six people can't give you much. Gerald's on the mike saying, "Come on ya'll! Put your hands together!" He's shouting like there are a thousand people out there. All of a sudden he gets mad and says, "Fuck ya'll!" I turned around and said, "Man, what did you just say?" Then he said it again, "Fuck ya'll people!"

Well, back then you did two or three different sets and we were just on the first one. So we finished the set, and afterward, in the dressing room, I say, "Man, you know you was wrong!" Now, just to paint the picture for you, I've always liked jewelry, but in the early LeVert days I had fake stuff. That night I was wearing a big fake diamond ring.

Gerald got mad after I yelled at him and wanted to fight. Usually I'd back down, but that night I didn't. I went at him first and caught him right in the eye with the ring and cut him. His eye swelled up really big. A nurse came in, cleaned him up, and we got ourselves together because we had to get back out there onstage.

We did our show just like everything was okay, in front of those same six people. Maybe two more came. The killer was

that after the show, the owner didn't even pay us. We had torn that dressing room up!

That's what I mean. Sometimes Gerald knew he was wrong, but he would hate to admit it. Eventually his conscience would get to him, and the next day or something, he'd say, "Hey, Man, okay, so maybe we should try it the other way instead."

That was my brother, though, and I loved him dearly. Gerald was my teacher. Just like he looked up to my dad, I looked up to him like that. He was my man! If anybody could talk to me and sit me down and tell me about what I needed to do, or what needed to happen, he could.

Now I have to do what Gerald always wanted me to do . . . make it happen! I'm keeping this music thing alive and what LeVert started going . . . for us!

Kenneth Gamble

Cofounder, Philadelphia International Records, and one half of legendary writer-producer team Gamble and Huff

I've always admired The O'Jays. They used to come to Philadelphia and perform at the Uptown Theater. They were one of my favorites, and I never even dreamed that we would be able to work with them one day.

Me and my writing partner, Leon Huff, were introduced to them by a disc jockey who used to be in Cleveland; his name was Ed Wright. We used to talk to Ed a lot, and we found out The O'Jays had a manager, Jewels Berber. We were just getting started with our company, and Huff and I used to sit around and say, "Well, who would we like to work with?" And the reason we picked certain artists was because they had unique voices, and nobody else sounded like them.

Eddie Levert was one of those kinds of voices at that time. Nobody sounded like him. Same with Lou Rawls, nobody sounded like him. Little Sonny from the Intruders, too, people like that had very unique-sounding voices. Until Gerald started to grow up! Then he started to sound almost just like Eddie. So there were two of them on the planet.

Eddie's DNA was definitely transferred to Gerald. If you ever got a chance to see them perform, they were like one person. I think Gerald picked up many of Eddie's body movements onstage, and his showmanship. Gerald was an excellent performer, just as Eddie has been a tremendous performer, along with The O'Jays.

Eddie was very fortunate to have had a son like Gerald. Gerald first had the talent, and second, he was able to make a career out of that talent. Gerald also was not just about being Eddie's son. He's an individual himself. It reminds me of the old days, I used to tell them many years ago, when Gerald and Sean were growing up and they wanted to record, that they should join The O'Jays. That was my suggestion, which I think they all booed me on. I thought they should've been in The O'Jays like the Mills Brothers, or the Ink Spots.

There have been very few family groups. The O'Jays' legacy has got to go on forever, and ever, and ever. I thought that Gerald and Sean would fit perfectly into The O'Jays and give them a new audience. But it all worked out well for them (Gerald and Sean) to be LeVert, and all is well the way they did it themselves.

I can't think of another father-and-son team in the industry today, in this generation, that not only has the talent, but also the ability of Gerald and Eddie. I don't know of any other group. I don't even know of a mother and daughter. As father

and son, I think that they were unique as it relates to the American music scene.

The relationship between Eddie and Gerald, and also with Sean, symbolizes what kind of father he was. He had to be a very attentive father, and he had to have made an unbelievable impression on his sons. He was able to groom them. I'll say it again, you've got to have the talent; no matter how much you want to sing, if you don't have the talent, it's not gonna happen.

They represent family. They represent what the African American community needs very very much. It needs to concentrate on how to help each generation get to a point where they have a better quality of life. The concept of father and son is probably one of the oldest American traditions there is. You have so many businesses that are named "father and son" plumbers, father-and-son carpenters, father-and-son home installation, I mean you can go on and on. I've even seen something lately that said father and daughter. So it's changing as the years go by.

The bottom line of it is that in the music industry there is not to my knowledge any father-and-son relationship that is as popular and also a crowd pleaser. It was truly unbelievable to see Eddie and Gerald perform together. They were friends and business partners. But the most important thing was that, at the end of the day, they were father and son.

Sylvia Rhone
President, Motown Records;
signed LeVert and Gerald as a solo artist

It's incredible when you consider that one family has delivered a combined seven decades of music, going back to the

dawn of the 1960s, when Eddie and The O'Jays started at King Records in Cincinnati. Talk about passing the baton. I remember when I first saw LeVert twenty years ago; all you had to do was close your eyes and you weren't sure if you were hearing Eddie or Gerald or Sean. There is a legacy of talent in that family that is incomparable.

It's as if a mirror image of the father had been bestowed upon the sons—Gerald and Sean. Two generations of music that have altered the R&B landscape forever. Another tribute to Eddie's mentoring is the maturation process Gerald exhibited throughout his career. I remember when he and I started out. We grew up together in this business, experienced a lot of successes, and had our share of trying times.

I think Gerald and Eddie would also tell you they challenged each other from time to time, like all father-and-son relationships. But I've never seen a father exhibit stronger paternal and protective instincts than Eddie Levert. And I know firsthand that Gerald cherished everything his father taught him about keeping your integrity and still succeeding in this business.

I'll never forget when I first went to Philadelphia to meet Eddie to discuss his sons and the group LeVert. He drilled me on what he expected for his sons, and what expectations he had for their success and well-being as people.

The real proof is in the music, of course: the legacy. Begin with Eddie and The O'Jays' accomplishments—in the seventies alone they had seven number-one singles and a decade's worth of gold and platinum albums—and then consider how seamlessly he passed the mantle to his sons. LeVert had an unbroken string of eight gold albums.

And Gerald—a force of nature unto himself, a multiple

Grammy nominee and NAACP Image Award–winner who through the years has become so much more than an artist—he was my compatriot, my friend, my fellow traveler, and brother-in-arms who put up amazing numbers in his career: nearly 20 number-one hits, 12 gold/platinum albums, selling well over 12 million albums.

The Leverts are one of the seminal family entertainment dynasties of the last fifty years. Together, Gerald and Eddie literally transformed American black music, and perhaps most important, exemplified the power and resonance of the African American family. They not only set an example for black fathers and sons, but inspired families everywhere at a time when sons and daughters—and yes, moms and dads—needed that kind of reassurance more than ever.

When Eddie and Gerald were recording *Father & Son,* the true signature album of their relationship, those of us who were fortunate enough to be in the studio would often leave crying—the music and the message they were delivering was that powerful. People would come to their concerts—fathers bringing their sons, mothers bringing their children—and wait for hours to see them after the show, with tears in their eyes, to see how Eddie and Gerald's legacy of love and affection had positively affected their own family unity.

Patti LaBelle

Legendary singer, bestselling author of
Don't Block the Blessings

Eddie and Gerald's music is the soundtrack of my life. When you listen to them, you hear and feel sex, dancing, rhythm, and feel like crying. Eddie is a very sexy man . . . he is

so not afraid to speak his mind. These two were born to sing. Gerald followed in his father's footsteps and was a Mini Me of Eddie. They will always be one of a kind, and that's a beautiful thing. Their legacy as a classy father-son act showed that father and son can do a lot together.

I heard guys talking about how Gerald had the nerve—he just had the nerve to roll on the floor like Miss Patti! I thought he was going to kick off his shoes. I said, "Gerald, I'm gonna have to pimp slap you!" He said, "Just do it right. If you gonna slap me, slap me right." I called him "the mock Patti LaBelle" 'cause he was rolling like nobody's business and just, like, one of the best singers in the world.

So we have a big ol' gap now. When Luther left, and back in the day when Marvin (Gaye) left and Curtis Mayfield, and Ray Charles left, and people who didn't sing, like Richard Pryor, like Ed Bradley, Nina Simone . . . so many soldiers are gone. All I can say is we must celebrate, and there can be no pity parties because Gerald was a party animal . . . just fun.

Tom Joyner
Radio personality

As a black man in business with my two sons, Thomas and Oscar, I think it's important to let the world know about other success stories like Gerald and Eddie, a true father-and-son team. Eddie and Gerald were not only harmonious in their music, but harmonious in their relationship as well.

Long before Gerald was a household name or a heartthrob, Eddie Levert and The O'Jays had begun earning their places in R&B music history with years and years of hits dating back to the 1600s. Yes, I said 1600s. Their seventies R&B "anthems"

like "Family Reunion," "For the Love of Money," and "Living for the Weekend" are as familiar to Black America as "Lift Every Voice and Sing." But what made The O'Jays stand out from so many R&B groups of their era is that they managed to stay so current. I think this was due in no small part to Big G (Gerald), and his close relationship with his dad, as well as to the other members of the group, Walter and Eric.

When Gerald stepped into the spotlight, first with the group LeVert and then as a solo act, it didn't take long to recognize that he had true star quality, professionalism, and that Eddie Levert couldn't deny him if he tried! Forget DNA, play "Pop, Pop, Pop, Pop Goes My Mind" for all the paternity evidence you need.

Over the years, Gerald got better through the "old schooling" he got from Eddie. There came a time when the script was flipped and the two began to learn from each other. That kind of give-and-take is the key to any good relationship, and fathers and sons are no exception. But too many times, fathers have the attitude that they know it all and it's their job to play the teacher's role forever.

It's when we fathers realize that our sons have remained in our lives so that they can begin to teach us a few things that we have the kind of relationship we really strive for—mutual love, mutual respect, and mutual laughter, not to mention mutual paychecks! Hey, when your son can pick up the tab, it's a wonderful thing!

I don't think anyone who was ever in the presence of Gerald and Eddie had any doubts about the love and respect and good times they shared. I'm sure they had their ups and downs, but it's exciting to read about how the two were able to smooth the rough edges and always have each other's backs. The two of

them bridged the gap between old school and new school and cemented a bond with music and love.

Reverend Run
Hip-hop icon, pastor, author,
and star of MTV's *Run's House*

When I think of Eddie, I think of longevity. When I think of Gerald and Eddie together, I had never seen anything like that in my whole life—seeing a father and son work together, seeing a son look up to his dad, and the type of success they had. The love they shared for each other, the way they talked to each other, the way they got along, and the music they made over the years is truly mind-blowing.

It's something that reminds me of my group, Run DMC. I always told people that I felt that we were more like thirty percent talent, seventy percent love. My point is that the love was really deep between Eddie and Gerald, and that's why God blessed them both with wonderful talent.

Eddie and Gerald showed unity, and seeing a father-and-son team of that sort was rare. Something about them almost seemed brotherly. I saw the admiration from Gerald for his dad, and the same in the way Eddie looked at and treated Gerald. He gave Gerald the chance to have tons of self-confidence, and I think that's tremendous. My prayer is that I can get that anointing that they had, for me and my son, JoJo.

Kevin Liles
Warner Music Group

Eddie and Gerald are one of America's favorite musical gifts to society and possess the power of timeless song. They created

the ultimate connection with their fans, one of great heritage through heartfelt lyrics and an understanding of the human spirit. I salute father and son, Eddie and Gerald Levert. The musical community is a better place because of their phenomenal contributions.

With the passing of Gerald, we have lost one of the greatest fathers, artists, and friends that I have ever had the opportunity to serve. Gerald Levert's heart and soul was poured into everything he did. His accomplishments have stood the test of time and provided us all with special moments that we will cherish for a lifetime.

The stage was his canvas and the microphone was his paintbrush. I thank Gerald for the many beautiful colors and some of the greatest paintings in rhythm and blues.

Jamie Foster Brown
Sister 2 Sister magazine

I remember Gerald telling me that he never understood why his daddy wasn't there for him. But once he followed in his daddy's footsteps, he understood why Eddie couldn't be with his family like other fathers. These two entertainers I consider friends. The joy I would get from one short visit with Eddie and Gerald could last me from January to Christmas. I love how they loved one another. And they shared their world with all.

Gerald would call me and give me his story before any other publication whenever something happened to him, whether it was a rumor about who he was dating, or anything happened to him with women, legally. He even told me who he was really in love with!

I don't go to a lot of concerts anymore, because I've been around the entertainment and music industry so long. I guess you could say I'm a bit jaded. But whenever Eddie and Gerald were in town performing, I'd stop what I was doing and go see them. They lifted my spirit with their music. They thought I needed them to give me their stories, but *I* was the one who needed them! They would bring an enormous amount of joy to my heart when I saw them.

Gerald is still very much in my head and heart. Sometimes it doesn't seem like he's really gone. He comes to my thoughts at night especially. And I have to say, "Gerald, get out of my bed! I'm a married woman!" I know he probably got a kick out of that. He had such a wonderful sense of humor and that great laugh!

I feel so much pain for Gerald's millions and millions of fans. They loved his music. Seeing the thousands, just in Cleveland, line up at his public memorial service gave me a deep feeling of happiness, and was confirmation that it's our duty in the media and the entertainment business to keep his legacy and music alive! I'm honored to have known Gerald.

Joe "Big Joe" Bailey
Bodyguard and friend

I met Gerald back in 1988 when I was playing basketball at the Levert home. We called it the Big House. I was originally brought in to do security for Sean and Marc. However, when we'd be out on the road, and Gerald was with us, I'd see him getting swamped by the fans and rescue him. That happened more and more. Eventually I ended up working for him exclusively.

Once I started working for him, he reminded me of how, back in the day, I used to drive a big white Cadillac, and at the

time I always kept a few ladies around me. Gerald told me he thought I was a pimp at first! Needless to say, I wasn't, but that's just one example of his amazing sense of humor.

We always saw eye-to-eye about life. Our birthdays are just a day apart, and I guess we just clicked. For a guy who had no education past high school, he had to be one of the smartest, wisest cats I'd ever been around. He just knew about life.

Everybody wants to talk about the bump 'n grind Gerald, but I know about the spiritual Gerald. I believe the last three gospel songs he recorded toward the end of his days will truly define his purpose with God. He wanted to just call them spiritual songs. I think mostly out of respect for his mother and his Jehovah Witness background.

I was listening the other day to one of those songs. It's called "I'm a Beggar," and he recorded it with Jeff Majors. I listened to it about ten times, back to back. It's a song about Jesus coming back and walking the earth and people saying to him, "What happened? You had so much, big houses and cars, and now you've turned into a thief?" And Jesus says, "I'm not a thief, I'm a beggar and I'm begging for Christ."

I know that part of his purpose was to bring people together with his music. So, if out of the millions and millions of fans he had, if he saved just one soul with his music, he did his job.

When you talk about greatness, there's a beginning, but there's never an end. That's how I feel about Gerald and his music. He kept twenty-one people on the payroll at all times, when he could've gotten away with half that amount. He carried some folks who didn't deserve it, but that's what kind of brotha he was. He took somebody like me out of the ghetto and showed me the world.

My number was the last number dialed in Gerald's phone, at about 3:00 A.M. I remember talking to him before that for about an hour and a half. I told him I'd be out there in the morning, but I never saw him again. I don't know if that call to me was for help. I'd hate to think I wasn't there for him when he needed me. I guess I'll never know.

Gerald knew he could've gone to the hospital that night, but sometimes you can't fight destiny. When I had a chance to finally see him after he passed, I whispered to him, "I'm so proud of you because you took your journey like a soldier and you did all the things you had to do." I thought about how my parents had died when I was eight and ten years old, and that I practically had to raise myself after they were gone. Also, I decided at that moment that when it's my transitional turn, I don't want God to send my father, or my mother. I told G, I want God to send him to come and pass the torch to me.

I remember one time we were doing a rehearsal for a show and there were people casually milling about, but I remember, out of the clear blue sky over the mike, Gerald shouted, "Big Joe?" I said, "What's up man?" And he shouted back, "Don't ever leave me, Man!" My name is Joe Bailey, but Gerald created the nickname "Big Joe" for me. I told Eddie the Saturday following Gerald's services that I had to send "Big Joe" with Gerald. He's gone now. Joe Bailey is back.

Edwin "Tony" Nicholas
Music collaborator and friend

The thing that makes my perspective of Gerald different than everyone else's is that I sat in the studio with him and saw him live the stuff that became his messages. In many instances

he's singing about my life just like he's singing about his. I saw his songs from the inside out.

Our lives were in what I call a parallel universe. A lot of the things he was singing about would be happening to me. We shared experiences with "baby-mama drama," as well as career highs and lows. Often he used my relationships as fodder for some of his lyrics.

In 1988, I was the musical director for a group in Columbus, Ohio. The group LeVert's musical director heard about me and wanted me to cowrite some songs with Gerald's group, the Rude Boys. Turns out the keyboard player in LeVert quit, and I lied and told them I was a keyboard player. So here I was, this bass player, pretending to be a keyboardist. I had to because the musical director was a bass player.

I started touring with Gerald, Sean, and Marc, and at the same time became songwriting partners with Vert. Eventually, when Gerald decided to embark up on a solo career, Vert suggested my name to Gerald as a person who could help him make the album sound different than the LeVert records.

When we got together to do the first album, *Private Line,* it was a smash and we just kept doing it. I knew how to play, but it was really just a tool to get my songs out.

I also ended up becoming Gerald's musical director in 1990 for his own band.

There were only two points where we parted ways. One time was for about a year when he recorded the album *G Spot.* Gerald also had the LSG project. I was going through some "baby-mama drama" and I had to quit the LSG tour to come home and go to court.

Gerald was angry, and it took him a minute to forgive me

for that. What he didn't understand was that I wasn't like him. Gerald had a staff who could handle things for him. I didn't have that. He ended up making the album with another producer, but at the end he got nervous and asked me to contribute a song for the album because he had never done an album that I didn't play an instrumental part in.

The second time was when Gerald was working on producing a group, and at the same time I had a solo artist signed to my company. However, neither worked out, and we decided from all this that we were much better together than apart.

One of my most memorable times working with Gerald was when we first recorded "Baby Hold On to Me." We both thought it was a great song, but the closest we ever came to falling out bad was then. He told me he was going to take it off the album, because he thought it was too soft. I told him, "Man, I will cut you if you take that song off the album!" I was serious, and Gerald thought about it and said, "Well, if you feel that strongly, then I'm gonna leave it." It wound up being one of the biggest songs he ever recorded.

Gerald constantly second-guessed himself, and record labels can make it difficult because they have an idea of what they want you to be. As an artist, it can mess with your creative process, because you're trying to give them what they want instead of just being what you are. Some of the greatest music he's done hasn't been commercially released. Maybe someday it will be.

When Gerald first met me, he didn't like me. He told me he was looking for every reason to fire me. He thought I was a smart-ass. I didn't know I was supposed to kiss his ass. Over time we came to really respect each other on a different level. I

think a lot of this had to do with the fact that our relationship wasn't born from me being a "yes man." Therefore, when I told him I agreed with something, I really meant it.

It's still amazing to me how close we were. I always saw Gerald as my boss for a long time. I wanted to make sure I never forgot that I worked for him. After we went through that rough period with *G Spot,* I knew we were tight. I told him, hey, let's forget about the music, I'd rather have you as a friend.

In May of 2007, it would've been nineteen years that Gerald and I worked together as collaborators. What affects me the most, now that Gerald's gone, when I listen to the songs other people hear, is that I really know what those songs meant.

Andy Gibson
Cousin and business manager

Gerald was my cousin, but he was really more like my little brother. He was nine years younger than me. In the summers when I was a teenager, I'd come up from Canton, Ohio, when Eddie was out on tour or recording, and I'd take Gerald to piano lessons and Sean to drum lessons.

I always wanted to be in the music industry. I was an accounting major in school, and Eddie told me that we needed someone in the family in accounting. So after about three years of college in Cincinnati, I told Eddie I needed to come live with them.

In 1979, I moved into their carriage house. Gerald was about thirteen. I actually lived there for several years. At that time I saw Gerald every day. He was always writing songs, and he'd bring them over to the carriage house for me to see what he was doing. Over the years I saw his development. By the time

he was eighteen, he got a group together with Sean and Marc. But he was always the leader.

My father had a truck in Canton, and I'd go get the truck on weekends and cart around all their equipment to their local gigs. They were gaining popularity as LeVert. At first people didn't take them seriously because of the name. They thought they were just doing music because they had a famous dad. Gerald was so meticulous about the shows.

They'd cover top twenty songs, but Gerald would always throw his original songs into the show, too. When they sang Prince or Whitney Houston, they'd also put their own spin on the song. LeVert's following just kept growing and growing. LeVert even got a little record deal and some regional play with a song called "I'm Still" on Harry Coombs' label.

After Gerald graduated from high school, Eddie wanted him to go to college, but the group was rolling and college wasn't in Gerald's plans. They got their big deal at Elektra, and from the time LeVert hit with "Pop, Pop, Pop" all the way through Gerald's solo career taking off, it was nonstop hits.

Gerald had a strong run until 2004, when things started to slow down. That's almost eighteen years! Gerald studied his music and the charts. As music changed, he evolved his music to make it relevant, but he never lost the essence of Gerald Levert, solid R&B.

Gerald was comfortable onstage by himself, in a duet, or in a trio. For some artists, if they're used to being solo, it's hard for them to go back into being in a group, or vice versa. Gerald always added something to whatever entity he was in.

Musically, I don't think he got the recognition he deserved. Some of his best songs never got released as singles. I hope now

fans, old and new, will go back and listen to those old albums and find the great songs that were never heard on the radio.

In 1986, when we started Trevel Productions, it comprised Gerald, Sean, Marc, and me. Since I was the oldest, my role was to steer the ship, get the infrastructure in place, the accounting system set up, and build a studio and rehearsal hall while LeVert was out on the road. We started in the basement of their family home, and in 1987 we moved to the Trevel Productions building. Our goal was to be another Motown.

We were getting acts and grooming them, and Gerald and Marc wrote some great songs for other acts. We got good airplay with our groups, too. Unfortunately, we weren't getting the record sales. Gerald's career was on fire, but some of the groups got envious. Gerald decided it was best to back away from us being a full-blown management and production company, and focus on producing and his solo career.

Gerald was now able to produce artists he had grown up listening to, like Teddy Pendergrass, Anita Baker, Barry White, and The O'Jays. They were some of his heroes in music.

We downsized Trevel, and at the same time Gerald and Marc hit a fork in the road professionally, they made a split, and we bought Marc out. Gerald and I went through a lot of changes and took quite a few bumps together, but the key word is "together."

One of the things I'll always remember about Gerald was that he was a hard worker who took pride in his work in the studio and onstage. He would spend hours in the studio. It was hard for anything else to give him the same passion, desire, and fire that music provided for him. I think he had in his mind that until he got that big hit, he'd just stay on the grind. As a family, we'd try to get him to go on vacation, but he refused.

I had a brother who happened to work for The O'Jays back in 1972. He was nineteen. The O'Jays went to London to do the album *The O'Jays Live in London.* He died out on the road with them.

I was sixteen and the loss was devastating. Gerald helped fill that void. He became my little brother, and Gerald would do anything for me, and I'd do the same. We didn't have to tell each other that, we knew we both had each other's back.

I will miss the conversations we had. We had a relationship where we didn't have to see each other every day, we talked on the phone a lot. I didn't even go out on the road much with him. When you're in business with family, you have to separate family and business. For the most part we did a good job at that. We disagreed, but we didn't argue much.

Gerald was my business partner, the best man in my wedding, my brother, and more important he was a good guy with a big, big, big heart.

Marc Gordon
Childhood friend and LeVert member

We didn't know what it was going to turn out to be. I didn't have a clue about being onstage in front of thousands, or having a song on the radio. It was the love of music that brought us together. I'd heard of The O'Jays, but I wasn't aware of the magnitude of their stardom.

I'd just started high school when our mothers brought us together. Gerald was two years younger than me and we went to rival high schools. My mom knew I was interested in music and she took me to their house. I got there and immediately sat

down at the piano and started playing. From that moment on we became best friends.

When I went back to Cleveland after many many years for Gerald's funeral services, I was almost in shock. I didn't realize how big the "LeVert thing" had gotten. There were thousands of people singing our songs and expressing their love and support for of course Gerald, but also for us as a group. We took a lot of people with us on the LeVert journey.

Gerald and Sean had so much musical history with Vert, and I learned a lot from them. We grew up together and went through a tremendous amount, from talent shows to small club gigs in front of two or three people, to get to the level of multi-platinum LeVert. We didn't make it automatically just because of the group's name. Gerald and I, we wrote together, and anyplace we could sing, we'd sing. He and I spent time in the Levert basement writing music. We heard a lot of "no's" and "You guys aren't good enough's!" But we didn't stop. We kept groovin' until we got it right. Our goal was to make it!

Gerald and Sean were like my brothers, and Vert was like the father I didn't have once our mothers introduced us. I was at their house all the time, and after a while I never left. It was a real family, and that's what I loved about it. The creativity came from the close-knit ties we had. We had great chemistry.

It was terrible when we parted ways after LeVert, but I was happy that we did make peace in recent years. The last time I actually spoke to Gerald at length was about six or seven months before he passed, but it was all good; we were going to do a LeVert reunion.

I think Sean and I have to make true on that plan. Now

more than ever LeVert needs to be back out. In 2008 it'll be twenty years ago that LeVert hit the music scene with our first big hit. At this point in the game it's not about competing, it's about reconnecting with our fans who knew us then. It's about making an impact again with Gerald spiritually being there and me and Sean doing it for him!

Steve Harvey
Radio host, comedian

My relationship with Gerald Levert was special because it was built on honesty, which was one of his best traits and I think mine, too. Friends in the truest sense of the spirit.

We didn't spend a lot of time around each other because we were both busy, but I think the thing that enamored a lot of people to Gerald was the genius of him as a person. That's why his legacy and his funeral were so special.

People could feel his emotions in his performances and his singing. When he was writing and singing about stuff, you could tell what he was thinking and feeling. He wasn't just making songs for you to dance by. He was making songs for you to *feel* by. That's the difference between him and a lot of other artists. That's why I think his sudden passing was such a shock.

His relationship with his father is one that is not often portrayed or captured, especially in our community. But even amongst non–African Americans, what he and Eddie had was very special and hard to imagine for anybody. I had a special relationship with my father, but my father wasn't famous, and when you have two famous people who mirror each other, that's a special relationship for a father, to have a son who mirrors him.

I have that in my son, but to watch him grow and develop while his whole aim is to be you, that creates an incredible father-and-son bond. I think Gerald's whole aim was to become Eddie, and I miss that relationship for Eddie. My heart goes out to him each day. I can't imagine losing a child. But I think their legacy will continue. I think when Eddie tours, he'll talk about it.

The O'Jays and Gerald have become even bigger now, and it's sad that you have to lose a person in order for them to become bigger. They were great already, but I think this solidifies them as truly one of the greatest father-son teams in entertainment. It'll go down in history that way. Even if Gerald had not passed, it would still go down that way. We're all going to miss him, but not as much as Eddie will.

Walter Williams Sr.
The O'Jays

We are deeply hurt by the tremendous loss of our son, nephew, and close friend Gerald Levert. We watched him grow up and he developed into a fine young man, writer, producer and entertainer in this extremely tough world and business. God has blessed the road Gerald traveled. We may have lost him along the way, but he will forever remain in our hearts.

(As told to *Sister 2 Sister* magazine)

Eric Nolan Grant
The O'Jays

My funny story about Gerald is that I was doing a show in New Orleans at the Astrodome. And I had never done a show in front of 86,000 people before. So I said, "Gerald, how do

you perform in front of all these people?" And he said, "Well, what you do is you make all your moves bigger. When you make your moves bigger the people will be able to see you in a big way."

Okay, so I get on stage, I'm doing "For the Love of Money," and the next thing you know, I tried to make my moves bigger, did a split, almost fell, and tore my butt up. I looked back and Gerald was laughing. He was on the floor!

Gerald is my brother and I'm gonna miss him!

(As told to *Sister 2 Sister* magazine)

Alan Haymon
Concert promoter and friend

Gerald Levert was one of the finest young men I ever had the pleasure of knowing in any walk of life. The only thing about Gerald that surpassed his enormous musical talents was his character and sense of decency. Simply put: He was one of the best human beings I ever knew. I will always love him like a little brother.

Martha Levert

Gerald's mother

"First born, I miss your smile and I miss your laugh! This was your favorite dish, but Mom's love was always the secret ingredient!"

Love, Mom

MARTHA LEVERT'S FAMOUS NECKBONES AND RICE

2 pounds of fresh pork neckbones

Lawry's seasoning salt

Black pepper

Garlic powder

Butter

2 cups of white rice

Clean neckbones. Put in a large pot and cover with water. Add Lawry's, black pepper, garlic powder, and butter. Boil until tender and falling off bone (45 minutes to 1 hour). Add rice and cook an additional half hour to 40 minutes. Note: When water runs low, remove from eye and keep covered. Serve with a salad and hot-water cornbread or Jiffy cornbread.

Now's the time for all the people to speak in one voice

Unity we must have unity

—"Unity," K. Gamble, L. Huff /
The O'Jays,
When the World's at Peace

Eddie and Gerald's extraordinary father-and-son collaboration is a beautiful bond as black men, as father and son, and as friends and business partners. Therefore, who better than Eddie and Gerald to "represent" the motivation and attitude of this ever-increasing collective spirit?

The loyalty, love, respect, and responsibility that organizations and conferences like 100 Black Men, The Black Fatherhood Summit, The African American Male Empowerment Summit, the Male Development and Empowerment Center, Proud Poppas, and

the Real Dads Network all speak of are synonymous with Eddie and Gerald Levert's music.

As Gerald said: "My dad and I knew we couldn't put this book out without shining the spotlight on the folks who are in the trenches, working hard every day to help other black fathers reconnect with their children, support one another, and build better lines of communication within the black family structure." The following pages include the voices of some of the community heroes and sheroes Eddie and Gerald applaud.

Joel Austin
Founder and CEO, Daddy Universe City

Coming from my perspective as the founder and CEO of a fatherhood organization, I feel that Eddie and Gerald Levert give us a true picture of what can happen if you stay together as a family, and if you communicate with your child. Eddie can be used as an example that you can be appreciated and adored by your son. From the same point of view with Gerald, he showed that you can have a father that you are proud of. In our community that's a very strong thing. We need solid evidence, and Eddie and Gerald are the solid evidence.

With my organization, Daddy Universe City, we recognize there's a need for us to alert the world that the key to all of our problems is in the family dynamic and the family dynamic is the mother, the father, and the child. Eddie and Gerald have both expressed these issues and themes in their music.

Research proves that the more involved a family is, no matter whether we are married, divorced, the more the father and mother are involved in a child's life, the better that child is. And over time, the better the world will be.

Grassroots organizations like ours are solving problems from the inside out. I tell men, you are the solution, women set the tone, but you are the solution. What are you going to do about your community and about your world?

The most important thing is having someone who can talk to these young men, because one day your daughter-in-law may ask, "What did you do? What kind of man did you give me?" You don't want to be embarrassed. We tell mothers, Hey, the same kind of man you're looking for is the same kind of man you need to be raising.

Adeyemi Bandele
Executive Director, Men on the Move

Eddie and Gerald's music represents passing on the tradition, and covers the spectrum of styles from two different generations. Seeing them perform together absolutely touched my soul in a special way. They sent a message of what a positive father-and-son relationship looked like. Gerald's death makes it even more necessary to keep that message going, because today we are faced with generations of fathers and sons who are incarcerated, sometimes in the same institution.

We also have Jesse Jackson and Jesse Jackson Jr., and Tom Joyner and his sons, Thomas Jr. and Oscar. I am also proud of my son, Lumumba Bandele, who continues in the tradition of activism for social change. Our community needs more of these relationships highlighted in order for the example to be replicated over and over again.

Men on the Move applauds the legacy of Gerald Levert. And as only one of many organizations that are part of the Fatherhood Movement in this country, we are committed to

supporting fathers in being the best fathers, sons, husbands, lovers, and friends. We encourage men to become "village dads" to children who may be without biological fathers.

Many children carry the anger toward their father into their own relationships and, as a result, experience failed relationships and don't understand that the root cause has nothing to do with their partner and everything to do with their anger.

The emphasis on fathers who have not been active in their children's lives comes at the expense of failing to recognize and give credit to those, like Eddie and Gerald, who have been on the front line, remaining steadfast as supporters and providers to their children. Because of Gerald, we can expect to see more children following in the footsteps of their parents.

Reggie Rock Bythewood

Member, B Dads

Gerald Levert was an incredible singer in his own right, just as Ken Griffey Jr. is a star baseball player. But the fact that Ken Griffey Jr. is the son of Ken Griffey Sr. raises the level of awareness and meaning of a son following in his father's footsteps. Gerald and Eddie represent the same thing as icons in music.

To have two grown men singing "Wind Beneath My Wings" is motivating, but especially for fathers. All fathers want to be heroes to their sons. When my boys are grown men I hope that our friendship and bond will be as strong as the one Eddie and Gerald had.

Alicia Crowe

Attorney and author:
*Real Dads Stand Up! What Every Single Father Should
Know About Child Support, Rights and Custody*

Eddie and Gerald's father-and-son legacy is invaluable to us as a people, because they showed us what's possible if we stay connected to our families. Eddie and Gerald gave us a model. In my opinion, the black community isn't producing leadership in the conventional sense. However, what Eddie and Gerald represented together was leadership, through the arts, through their music. Artists are the most influential people, because unlike politicians, they're not trying to get reelected.

As an attorney, I see "my" people standing in long lines, wrapped around court buildings Monday mornings, fighting each other over their children and money. There's a stereotype especially in our community that men are good at making babies, and then leaving.

It started to register with me, how fragmented we really were. I wanted to give fathers a guide. There was nothing out there that explained to fathers the court process, what to do, how to try to settle with the other parent, even challenging and changing the laws so there's more fairness.

I also saw how women were deliberately keeping the children away from their fathers. My message to my sisters: Stop the baby-mama drama! Women don't realize the damage it does psychologically to the child, because they're so blurred with their animosity toward the father.

Gerald had a large impact on women with his music, and I hope that in his passing, his music lives on and aids in healing the anger that we seem to have toward our exes. Anger that

results in keeping our children from their fathers. It's not about Man vs. Woman. It's about the whole family.

Shawn Dove

Founder and publisher of *Proud Poppa,* a community-empowerment magazine created to Celebrate, Elevate, and Replicate fatherhood success principles in the black community

Lord, what a powerful picture to see a black father standing tall—leading and leaving his very own legacy of love, guidance, perseverance, spirituality, and creativity for his children, particularly his sons.

Eddie, in The O'Jays' memorable "Family Reunion" song, clearly outlines the role and responsibility of the father in the family as the head, leader, and the director. Gerald was proof positive that if our sons can see it they can be it! The key to the problems in the black community begins with the helping, honoring, and healing of black men and fathers.

Eddie and Gerald Levert created the perfect public platform with their relationship that amplified the growing call for black fathers to help positively shape the destinies of their children. Sadly, in my twenty years of youth development work I have seen too many fatherless young men on a parade to prison. The youth mentoring movement is in crisis.

Also, many adult black men today feel like they are stumbling through the dark in their fathering because they grew up without a framework for positive paternal leadership. They too need to know that someone has got their back along their fathering journey.

I Got Your Back hits the streets at a time when black men from the penthouse to prison are circling our collective wagons

to step up our games as fathers, whether it is seeking to atone for past absenteeism and neglect or coming to terms that our presence is so much more important to our children than our presents. On the pages of my magazine, *Proud Poppa,* you will find black men and fathers intimately sharing their purpose, presence, and power. The black community is in dire need of fathers who are willing and able to reclaim their positions as providers, protectors, planners, and prayer warriors for their families.

Derek Phillips
Executive Director, Real Dads Network

When I think about Eddie and Gerald's music, what stands out to me is the whole concept of family, families coming together and being together. Eddie and Gerald had a genuine love, and I think that's what people felt and that's why they were so loved by the community. Eddie is very adamant in showing the world his pride in his son.

The dynamic Eddie and Gerald shared is representative of what we at the Real Dads Network stand for. And that is encouraging men to embrace their role as fathers, husbands, and as leaders in the community. One of the biggest problems we have as men is that we don't always know how to express our emotions. The Real Dads Network provides an environment where men can talk.

Also, when you start looking at the social ills of our community, a lot can be attributed to the negative music many of the popular rappers are putting out because they don't have fathers present in their lives. An artist like Gerald Levert was never going to get up and start saying that women are bitches

and hos. Why? Because Gerald came from a solid foundation. His father was around. His father wasn't going to allow that.

In our culture it's always been about the African proverb "It takes a village to raise a child," but we must also remember the role of the mother and the father. The "village" represents our community and should be used as a support system for the parents. Our communities are exhausted because fathers and mothers are not working together.

The other thing we have to stay focused on is that the child comes first even if we as parents can't get along, we're divorced, or we're separated. We still have to have a commitment to that child, even without a commitment to each other.

Terrie Williams
Bestselling author, motivational speaker

Gerald grew up in the midst of his father's legacy and was well schooled in the art and fundamentals of authentic soul/ R&B music and singing. By nature and nurture, Gerald sounded a lot like Eddie. His music bridged the gap to today's generation by singing in a way that reflects the now.

Eddie and Gerald's musical legacy speaks to the crucial elements of commitment, love, and respect for women. All of which contributes to a mentally healthy African American community.

As I reflect on Gerald and the relationship he shared with Eddie, it was one of love, respect, brotherhood, and friendship that is unfamiliar to many in their daily lives. This book is an opportunity to highlight the healthy aspect of the trust and ability to confide in a father. The absence of this is a void that also must be recognized in single mothers raising boys.

It's not easy raising African American sons in America. The cards are stacked against them at birth, sometimes even before they are born. But, whether you are a mother or a father with a son, the single most important thing you can do for him is to just be there. Eddie and Gerald demonstrate this in *I Got Your Back*.

Reverend Alfonso Wyatt
Vice President, Fund for the City of New York

Eddie and The O'Jays' songs, as well as our late brother Gerald's, are symbolic for me as a leader and role model in the community. I've been involved in the work of community building, family preservation, and assistance to at-risk youth, or youth in general, because most are at-risk just by being alive.

People who've grown up with fathers have no idea what it's like to grow up without one. We see the issues, we see the problems, but we don't know how many of those young people, male or female, grew up in fatherless homes. I'm not blaming fathers, and I'm certainly not blaming mothers who are raising sons and daughters.

As an elder serving on the ministerial team of the Greater Allen Cathedral in New York, and in my position with the Fund for the City of New York, I help to bring both the secular and sacred communities together through grant support to help institutions and individuals who are concerned about family, and black men and boys.

I believe it's very important that "we" as a people support institutions and grassroots organizations that are involved in the preservation and stabilization of families in our communities.

The O'Jays sent these same messages in songs like "Survival" and "Give the People What They Want."

Epilogue
COAUTHOR'S REMEMBRANCE

JANUARY 9, 2007

At approximately one o'clock in the afternoon, I got the news on Friday, November 10, that Gerald had died. I was sitting in the dining room of legendary jazz musician Jimmy Buffett's penthouse apartment in Manhattan with my agent, Marie Brown.

Marie had asked me to escort her to Mr. Buffett's for a special *60 Minutes* taping, honoring her best friend, acclaimed journalist Edward Bradley, who had passed away the day before.

Earlier that morning, I had tried to reach Gerald several times to tell him I needed to push a noon

phone call with him and his dad back a few hours. I wanted to be with Marie, to support her after such a devastating loss. Gerald never answered his cell or home phone. I finally gave up and left a message, promising to call him later.

I never made good on that promise.

As I took in a breathtaking view of the Hudson River, the entire West Side of Manhattan, and parts of New Jersey, a gleaming Statue of Liberty caught my gaze. My cell phone rang and a voice calmly said, "You need to get someplace where you can talk." Instinctively, I knew something was terribly wrong. My heart rate quickened and I felt a knot form in my stomach.

I quickly replied in a whisper, "I can talk." There was a pause and the voice, belonging to my close friend Alan Haymon, said, "I think Gerald's gone." I was confused. There was another pause. "I think Gerald may be dead," he said slowly, in a low tone. I felt flushed. The knot in my stomach jumped to my throat. I raced into Mr. Buffett's kitchen, where the camera mikes couldn't pick up my voice.

In a panic, I began to question him. "What! What? What are you talking about?" He explained that he thought Gerald had had a heart attack, but he'd call me back when he was more certain. I hung up and speed-dialed Eddie. He answered on the first ring. "What's going on, Eddie?" I was shaking all over, trying hard to hold back my tears. "Is Gerald gone?" Eddie cleared his throat and in a low and shaky voice replied, "Babygirl, I'm afraid so."

I disconnected the call and slowly stumbled past Marie, who was in a corner quietly finishing a phone interview. She was momentarily distracted by the distraught look on my face. I pushed through a doorway and ended up in a guest bath-

room, where I collapsed on the sink and began to cry. After a few moments Marie came in to console me.

Within minutes the word had spread throughout the apartment that Gerald Levert, son of legendary soul man Eddie Levert, had died. I felt terrible. I was supposed to be there comforting my grief-stricken agent, but it had all been turned upside down and inside out. Marie wrapped her arms around me and we began to cry together. One by one Mr. Bradley's friends, like Charlayne Hunter-Gault, and Mr. Buffett himself, offered their condolences.

Life seemed to move in slow motion after getting the news. Following the *60 Minutes* shoot, Marie and I ended up at the Hudson Hotel bar, where we both sat in a brain-numbed state for what felt like days. I'd start crying, then when I'd stop, she'd start, and this went on and on for what seemed like hours. By the end of what felt like the longest night in history, we found strength in each other's pain.

The next day, in the aftermath of hearing the news that my good friend and book collaborator Gerald Levert had passed, I needed to hear his music once more. It was the one thing he loved creating and sharing so much. I woke up at 4:00 A.M. humming his 2002 tune "Funny." I quickly grabbed my iPod, shuffled through my playlist, pressed play, and exhaled. The lyrics brought a bittersweet smile to my face.

On a day like today
Got outta bed
Nothing went my way
Tryin' to find some peace within
But there ain't no rest for a weary man

Everything seems to get me down
Looking everywhere to find a smile
Then the phone rings
And an angel sings . . . hello . . . hello
And it's funny you should call today

I began to relive my final conversation with Gerald, two nights earlier. He had called twice that day. The first time I missed him, but he left a message that simply said: "Lyah, Lyah, Lyah . . . Gerald, Gerald, Gerald . . . call me, call me, call me . . ."

We finally connected later that evening. My phone rang and the caller ID read Gerald 1. I smiled like I always did when he called. Something about hearing his gravelly voice and that infectious, hearty laughter was a lifesaver, especially on stressful days. I was anxious to hear about his and his dad's trip to South Africa.

Gerald sounded congested but was his usual jovial self. Before we could get down to the business of the book, we always had to do our personal updates. Forget mine; today I just wanted to hear about the Motherland. I told him that Andy, their cousin/business manager, was sending me photos.

"Oh, the ones with Mr. Mandela?" he asked.

"What! Ya'll met Nelson Mandela! Aw, I wanted to go!"

"You missed it. Sold-out shows with fifteen thousand people, and they were singing all the songs."

"They knew the words?"

"Every last one of 'em! And another thing, all I can say is that ya'll don't have booties over here! Sistas in South Africa got booties!"

"You are so silly, Gerald!" We laughed.

Gerald had a quick tongue, and like Eddie says, his smile and humor were "undeniably Gerald."

Gerald and I shared many honest conversations and rousing good times. All memories I will hold close to my soul forever. In a business where good-hearted, genuine people are few and far between, Gerald was one of those rare gems. He always encouraged me to keep pushing to break more barriers as a woman in the entertainment business.

There's something very special about a man and woman who find a connection and support each other's dreams, and it can be a relationship that is purely platonic. Ours was a friendship in its truest form. Gerald and I could go stretches of five, sometimes six months without talking, but then I'd get a call or reach out to him, and we'd pick life back up like no time had passed.

I owe the idea of writing a book with Gerald and Eddie to our mutual close friend, Alan Haymon. He planted the seed in my head, and it took me less than ten minutes to conceive what the book should be about—Gerald and his dad's unique bond as father and son and as friends. I called Gerald immediately, and without even consulting his dad, he quickly said, "Let's do it!" Later, I called Eddie to make the formal pitch, and he stopped me before I could finish with an enthusiastic "Yes!"

I want to thank Gerald for his laughter, friendship, love, and for touching my life along with so many others with his music. How miraculous that all the words fell into place on the eve he drifted away. When I close my eyes I can see that gentle smile. I think of Denise Williams's angelic voice when she sang "Black Butterfly." Gerald, now you're free and the world has come to see just how proud and beautiful you are . . .

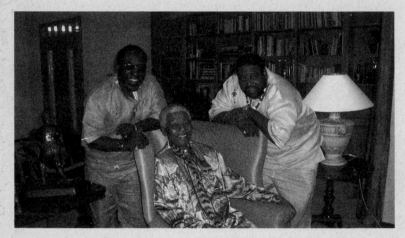

Gerald Levert's last public photo, October 2007, in South Africa.
Eddie Levert Sr., Gerald Levert, and President Nelson Mandela (seated).

Eddie Levert Sr. and Gerald Levert Discographies

THE O'JAYS DISCOGRAPHY

MAIN ALBUMS

Imagination, Music World Records, 2004

For the Love, MCA Records, 2001

Love You to Tears, Volcano Records, 1997

Heartbreaker, EMI America Records, 1993

Home for Christmas, EMI America Records, 1991

Emotionally Yours, EMI America Records, 1991

Serious, EMI America Records, 1989

Let Me Touch You, EMI America Records, 1987

Love Fever, EMI America Records, 1985

Love and More, Philadelphia International Records, 1984

When Will I See You Again, Philadelphia International Records, 1983

My Favorite Person, Philadelphia International Records, 1982

The Year 2000, Philadelphia International Records, 1980

Identify Yourself, Philadelphia International Records, 1979

So Full of Love, The Right Stuff Records, 1978

Travelin' at the Speed of Thought, Philadelphia International Records, 1977

Message in the Music, The Right Stuff Records, 1976

Survival, Epic/Legacy Records, 1975

Family Reunion, Philadelphia International Records, 1975

Live in London, Philadelphia International Records, 1974

Ship Ahoy, Epic/Legacy / Philadelphia International Records, 1973

Back Stabbers, Epic/Legacy Records, 1972

The O'Jays in Philadelphia, Epic/Legacy Records, 1969

Back on Top, Bell Records, 1968

Soul Sounds, Minit Records, 1967

Comin' Through, Imperial Records, 1965

COMPILATIONS AND SOUNDTRACKS

Pride (soundtrack), Lion's Gate Records, 2007

Beautiful Ballads, Sony Music, 2006

Madea's Family Reunion (soundtrack), Motown Records, 2006

R&B Christmas Classics, Rex Recordings Inc., 2005

Hitch (soundtrack), Sony Music, 2005

Midnight Soul: Late Night Love,
 The Right Stuff Records, 2005

Black Power: Music of a Revolution,
 Shout Factory Records, 2004

Slow Jams: The Timeless Collection, volume 9,
 Capitol Records, 2003

Soul Love 80s, Madacy Records, 2003

The Fighting Temptations (soundtrack), Sony Music, 2003

Soul Funk 80s, Madacy Records, 2003

Soul Love 70s, Madacy Records, 2003

The O'Jays vs. the Whispers, The Right Stuff Records, 2003

I'll Be Sweeter Tomorrow: The Bell Sessions 1967–1969,
 Sundazed Music Inc., 2002

Music Legends: Classic R&B, St. Clair Records, 2002

Music Legends: Soul in the 70s, St. Clair Records, 2002

Soul Classics Volume 1, Collectables Records, 2002

Soul Classics Volume 3, Collectables Records, 2002

Soul Classics Volume 4, Collectables Records, 2002

Undercover Brother (soundtrack), Hollywood Records, 2002

Philadelphia Classics, Sony Music, 2002

Philly's Super Soul Hits, Sony Music, 2002

Say It Loud! A Celebration of Black Music in America,
 Rhino Records, 2001

The Ultimate O'Jays, Sony Music, 2001

Entertainment Weekly: The Greatest Hits 1973,
 Buddha Records, 2000

Pop Music: The Golden Era, 1951–1975, Sony Music, 1999

The Best of The O'Jays: 1976–1991, The Right Stuff Records,
 1999

Muppets from Space: The Ultimate Muppet Trip (soundtrack),
 Sony Wonder, 1999

The Best of Old School, AMW Records, 1999

Smooth Love, AMW Records, 1999

Sinbad's Summer Soul Jam: Live, EMI Records, 1998

In Bed with the O'Jays: Greatest Love Songs, Capitol Records,
 1996

WDAS 105.3 FM Classic Soul Hits, Collectables Records, 1996

Soul Train 25th Anniversary Hall of Fame (box set), MCA
 Records, 1995

Love Train: The Best of The O'Jays, Epic/Legacy Records, 1994

Bob Dylan: The 30th Anniversary Concert Celebration,
 Sony Music, 1993

Greatest Hits, Sony Music, 1989

Collector's Items, Philadelphia International Records, 1977

Best of The O'Jays [Philadelphia], Philadelphia International
 Records, 1972

GERALD LEVERT DISCOGRAPHY

MAIN ALBUMS

In My Songs, Atlantic Records, 2007

Do I Speak for the World, Atlantic Records, 2004

A Stroke of Genius, EastWest Records, 2003

The G Spot, Elektra Records, 2002

Gerald's World, Elektra Records, 2001

G, EastWest Records, 1999

Love & Consequences, EastWest Records, 1998

Groove On, EastWest Records, 1994

Private Line, EastWest Records, 1991

WITH LEVERT

Whole Scenario, Atlantic Records, 1997

ABC 123, Atlantic Records, 1993

For Real Tho', Atlantic Records, 1993

Rope a Dope Style, Atlantic Records, 1990

Just Coolin', Atlantic Records, 1988

The Big Throwdown, Atlantic Records, 1987

Bloodline, Atlantic Records, 1986

I Get Hot, Tempre Records, 1985

WITH EDDIE LEVERT

Father & Son, EastWest Records, 1995

WITH LSG

LSG 2, EastWest Records, 2003
Levert, Sweat, Gill, Elektra Records, 1997

COMPILATIONS AND SOUNDTRACKS

Voices, Atlantic Records, 2005
The Best of LeVert, Rhino Records, 2001
Jason's Lyric (soundtrack), Polygram Records, 1994
Mississippi Masala (soundtrack), Dead Line Records, 1992
New Jack City (soundtrack), Giant Records, 1991
Jumpin' Jack Flash (soundtrack), Musicrama Inc. Records, 1995
Coming to America (soundtrack), Atco Records, 1988
Action Jackson (soundtrack), Lorimar Records, 1988
Madea's Family Reunion (soundtrack), Motown Records, 2006

AAA Parent Coaching Services
AAA Parent Coaching Services exists to help all parents
be the parents they want to be every day.
http://www.aaaparentcoach.com

African American Male Leadership Institute
Richard A. Rowe serves as the Executive Director of the
African American Male Leadership Institute (AAMLI).
Correspondence may be sent to
AAMLI
P.O. Box 32025

Baltimore, MD 21208
(410) 637-5564
(410) 602-8067 (fax)
AAMLI51@aol.com

A Good Black Man, Inc. (AGBM, Inc.)
D. Anne Browne serves as the President of AGBM, Inc.,
which enhances the educational experience of young
African American males ages 11 to 13 with computer
literacy training, career awareness activities,
empowerment workshops, and leadership training.
P.O. Box 692
Randallstown, MD 21133
info@agoodblackman.com
www.agoodblackman.com

Alicia Crowe
Attorney and author: *Real Dads Stand Up! What Every
Single Father Should Know About Child Support, Rights
and Custody*
www.realdadsstandup.com

At-Risk.org
At-Risk.org is a resource for parents and the general
public in search of information about at-risk youth.
This site provides information and articles about helping
at-risk youth.
http://www.at-risk.org

B Dads

Members have made the commitment to be the best fathers they can be. The organization started when a group of four fathers decided to get together to watch *Monday Night Football.* Those four members have now grown to forty members. The group meets monthly for "Words from the Wise," during which older, experienced fathers who have raised grown children come and share their stories. The fathers also get their children together to do fun cultural events.

B Dads sponsors Little Legs, Big Hearts, an annual quarter-mile run for kids ages one to eight years old to raise money for the Sickle Cell Foundation. The group also feeds hundreds of homeless families each year on Father's Day.
www.bdads.org

Black Woman and Child

Black Woman and Child is a print magazine dedicated to serving the interests of Black women who are pregnant, plan to become pregnant, or have any children seven years old or younger. This group facilitates discussion regarding pregnancy and parenting issues.
www.blackwomanandchild.com

Daddy Universe City

Joel Austin, founder and CEO
www.daddyuniv.com or info@daddy univ.com

Dove Ventures, LLC, and Proud Poppa Publications
 Shawn Dove, founder and publisher of *Proud Poppa*
 Proud Poppa is a community-empowerment magazine
 created to celebrate, elevate, and replicate fatherhood
 success principles in the black community. Dove has
 more than twenty years of experience designing and
 implementing innovative youth development and
 community-building strategies.
 www.proudpoppa.net

Fathers Incorporated
 Mr. Kenneth Braswell serves as the executive director of
 Fathers Incorporated.
 P.O. Box 738
 Latham, NY 12110
 info@fathersinc.org
 www.fathersinc.org

Fund for the City of New York
 Reverend Alfonso Wyatt, Vice President
 121 Sixth Ave.
 New York, NY 10013
 awyatt@fcny.org
 212-925-6675 ext. 217

Head Start's 8th National Research Conference
 http://www.headstartresearchconf.net

Heart Touch, Inc.
>Heart Touch, Inc., is a nonprofit organization that provides training services for fathers to help them become more responsible.
>http://www.hearttouchinc.org

MAD DADS
>MAD DADS is an acronym for Men Against Destruction-Defending Against Drugs and Social-Disorder.
>MAD DADS, INC. was founded in May of 1989 by a group of concerned Omaha, Nebraska, parents who were fed up with gang violence and the unmolested flow of illegal drugs in their community. The MAD DADS are positive role models and concerned, loving parents who are a visible presence in local neighborhoods, and stand against the negative forces destroying children, families, neighborhoods, cities, and ultimately our country.
>555 Stockton Street
>Jacksonville, FL 32204
>904-388-8171
>www.maddads.com

Men on the Move
>Adeyemi Bandele, Executive Director
>2913 Georgia Ave., NW
>Washington, DC 20001
>240-432-6081

Mothers Raising Sons, Inc.

Mothers Raising Sons, Inc. is a 501(c)(3) nonprofit organization that provides comprehensive counseling, mentoring support, seminars, and educational services for single female–headed families to foster young boys in their transition to becoming successful men.
Lisa Norwood, Founder
P.O. Box 372951
Decatur, GA 30037-2951
(404) 247-1086
(404) 243-4233 (fax)
www.mothersraisingsons.org

National Fatherhood Initiative

The National Fatherhood Initiative's mission is to improve the well-being of children by increasing the proportion of children growing up with involved, responsible, and committed fathers.
101 Lake Forest Boulevard
Suite 360
Gaithersburg, Maryland 20877
301-948-0599

National Latino Fatherhood and Family Institute

Jerry Tello, Executive Director
5252 East Beverly Boulevard
Los Angeles, CA 90022
(323) 728-7770
nlffi@nlffi.org

National Partnership for Community Leadership
>Dr. Jeffrey Johnson, Ph.D., president and CEO
>The NPCL's mission is to target communities and
>families and provide empowerment solutions to those
>families for the future.
>202-429-2027
>www.npcl-ifc.org

100 Black Men of America, Inc.
>The mission of 100 Black Men of America, Inc., is to
>improve the quality of life within our communities and
>enhance educational and economic opportunities for all
>African Americans.
>141 Auburn Ave
>Atlanta, GA 30303
>404-688-5100

Real Dads Network
>Derek Phillips, Executive Director
>212-875-7725
>www.realdadsnetwork.com

Real Men Cook
>Yvette and Kofi Moyo launched Real Men Cook® in
>1990, which has become the largest family celebration in
>the country. Real Men Cook has been held annually on
>Father's Day for fourteen consecutive years. Today, Real
>Men Cook is the leading urban Father's Day experience.
>info@realmencookcom or
>whatscooking@realmencook.com.

EDDIE LEVERT is one of the founding members of the pioneering 1970s soul group and 2005 Rock and Roll Hall of Fame inductees The O'Jays. He lives in Las Vegas, Nevada.

Founder of the chart-topping group LeVert, GERALD LEVERT released his first solo album in 1991, and in 1997 formed LSG with Keith Sweat and Johnny Gill. Gerald also wrote and produced songs for many musical artists, including Barry White and Patti LaBelle. Gerald Levert passed away suddenly in 2006 at age forty.

LYAH LEFLORE is the coauthor of *Cosmopolitan Girls* and the author of *Last Night a DJ Saved My Life*. Lyah has been a television producer and entertainment executive for over a decade and has worked at Nickelodeon, Uptown Entertainment, and Alan Haymon Productions.

GERALD LEVERT | IN MY SONGS